The Art of
Japanese Calligraphy

Volume 27
THE HEIBONSHA SURVEY OF JAPANESE ART

For a list of the entire series see end of book

CONSULTING EDITORS

The Art of
Japanese Calligraphy

by YUJIRO NAKATA

translated by Alan Woodhull
in collaboration with Armins Nikovskis

New York · WEATHERHILL/HEIBONSHA · Tokyo

This book was originally published in Japanese by Heibonsha under the title *Sho* in the Nihon no Bijutsu series.

745.6
N14
c.2

First English Edition, 1973
Third Printing, 1983

Jointly published by John Weatherhill, Inc., of New York and Tokyo, with editorial offices at 7-6-13 Roppongi, Minato-ku, Tokyo 106, and Heibonsha, Tokyo. Copyright © 1967, 1973, by Heibonsha; all rights reserved. Printed in Japan.

Library of Congress Cataloging in Publication Data: Nakata, Yujiro, 1905– / The art of Japanese calligraphy. / (The Heibonsha survey of Japanese art) / Translation of Sho. / 1. Calligraphy, Japanese. I. Title. II. Series. / NK 3637. A 2 N 3213 1973 / 745.6'199'52 / 72–92096 / ISBN 0–8348–1013–1

Contents

147017

The Art of
Japanese Calligraphy

CHAPTER ONE

The Origins and Styles of Chinese and Japanese Calligraphy

IN THE WEST, calligraphy is generally associated with penmanship, and is mainly thought of as the art of writing neatly, but in China and Japan, because of the flexibility of the materials used and the graphic possibilities inherent in the scripts, it has attained to the status of an important art.

The Chinese language is written in a script consisting basically of pictographic and ideographic characters written downwards in vertical lines arranged from right to left. The Japanese imported Chinese characters, and their writing system uses these in combination with phonetic symbols called *kana*. Like Chinese, Japanese is written in vertical lines from right to left. Other arrangements do occur, but the one described above is the norm. Various materials have been used at various periods, but the most important of these by far is paper, which has a long history in China. Until modern times, the brush was the main writing implement, and characters were written in a kind of ink called *mo* in Chinese, or *sumi* in Japanese.[1] The art of

Chinese and Japanese calligraphy (*sho* or *shodo* in Japanese, *shu* or *shu fa* in Chinese) is basically the art of writing Chinese and Japanese characters with these materials. Nowadays, virtually all writing for practical purposes is done with pen or pencil, but brush-and-ink calligraphy is still widely practiced as an independent art.

THE ORIGINS OF KANJI Calligraphy is one of the most distinctive of East Asian art forms. It originated in ancient China, but did not become established in Japan until the introduction of Chinese culture in the Asuka (552–646) and Nara (646–794) periods. Since then Japanese calligraphy has developed ever influenced by Chinese styles. In Japan the so-called Chinese style (*karayo*) of writing, directly influenced by China, has been practiced consistently throughout history. However, since the two countries clearly differ in geography, climate, national character, and customs, a uniquely Japanese style of calligraphy called *wayo*, or Japanese style, was evolved. As opposed to *karayo*, it was the style that expressed the real individuality of Japanese calligraphy.

The Chinese style of Japanese calligraphy is

[1] With the exception of Chinese proper nouns, usually only the Japanese pronunciation of Chinese words has been given in the main body of this book. For the *kanji* and Chinese pronunciation of the names of script styles, however, see the chart on pages 14 and 15.

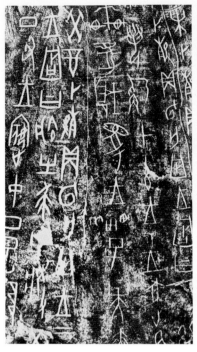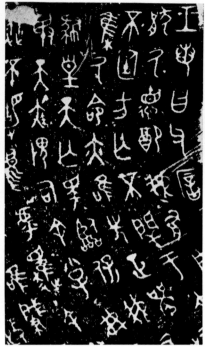

based on Chinese characters—that is, *kanji*. Almost all the characters used in Japan were created in China and have 3,000 years of Chinese history as a background. A few "national characters" were created in Japan, but since their structure is based on Chinese models, when we speak of calligraphy there is no distinction between Japanese and Chinese *kanji*. In other words, we should as a general rule consider all the *kanji* used in Japan from the standpoint of the principles and form of Chinese characters.

The first Chinese characters were primitive pictographs (*shokei moji*) depicting natural objects: the sun and moon, mountains and rivers, plants and animals; or things close to man's life: dwellings, utensils, clothes, etc. Notions of position, quantity, etc., were indicated by characters called *shiji moji* (symbolic characters; e.g., the Chinese word *hsia*, meaning "down" or "below," was

originally represented by a character consisting of two horizontal lines—a short one below a longer one).

Kai-i moji (combined-meaning characters) combine two characters into one (e.g., the Chinese word *hao*, "to love," was represented by pictographs of a woman and child next to each other).

Keisei moji (form-and-sound characters) are composed of two parts, one indicating pronunciation and the other meaning (e.g., the word *chan*, or "war," is represented by a character consisting of an element indicating the pronunciation *chan* and a pictograph of a spear).

Kashaku characters are borrowed (this is the literal meaning of the word) from the words they originally represented, and are used for words of similar pronunciation (e.g., the word *lai*, or "to come," is written with a character that was originally a pictograph of a kind of wheat called *lai*).

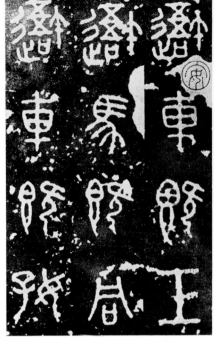
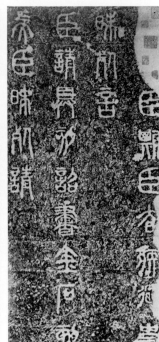

◁ *1 (opposite page, left). Inscription engraved on ox bone. Fourteenth to thirteenth century* B.C. *Ink rubbing.*

◁ *2 (opposite page, center). Inscription on bronze ritual vessel. Ninth to eighth century* B.C. *Ink rubbing.*

◁ *3 (opposite page, right). Example of* kobun *("ancient writing") in edition of* Shuo Wen Chieh Tzu *published in 1826. Top character of second column from right is the* kobun *character for "one." Naikaku Bunko Library, Tokyo.*

4. Daiten *(greater seal script) inscription on stone. About fifth century* B.C. *Ink rubbing.*

5. Shoten *(lesser seal script) inscription on stone. 219* B.C. *Ink rubbing; height, 111 cm.*

This can be regarded as a phonetic use of *kanji.*

Finally, there are *tenchu* characters. These are characters used in senses that differ from the original ideas they represented, the change having come about by a process of extension of meaning (e.g., the character for the word *e,* or "evil," can also be used as a *tenchu* character for the word *wu,* or "to hate").

Chinese characters were thus built on these six principles of construction—the *rikusho.* A *kanji,* of whatever kind, includes three elements: form, sound, meaning. From the point of view of calligraphy, form is the most important of these three elements because of the great potential for graphic variation that *kanji* possess.

To appreciate the graphic beauty of *kanji,* we can consider them from the three aspects of script style, character form, and general style. Let us first look at the script styles.

THE FIVE BASIC KANJI STYLES

In China, styles of writing changed several times in the course of history. The archaic characters of the oracle-bone (Fig. 1) and tortoise-shell inscriptions of the Yin dynasty (c. 1500–1100 B.C.) and the inscriptions on bronze vessels and bells (Fig. 2) of the Chou period (c. 1100–221 B.C.) show an as yet vague awareness of script style, and it is difficult to treat them as a calligraphic style. It is only with the appearance of two new scripts in the Warring States period (403–221 B.C.) that we can begin to think in terms of script styles. One is the *kobun* ("ancient writing") script (Fig. 3), as it is called in Hsu Shen's[2] dictionary *Shuo Wen Chieh Tzu* (c. A.D. 100), which was in use

[2] All Chinese names consisting of a family name and personal name in this book are given in Chinese order, i.e., family name first.

6. Korei *(old* reisho*) inscription on stone.*
56 B.C. *Ink rubbing; 26 × 25 cm.*

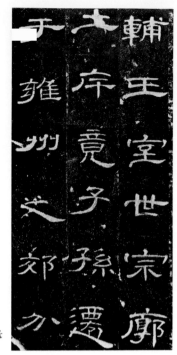

7. Kanrei *(Han* reisho*) inscription on stone.* A.D. *185. Ink rubbing; 23 × 11.3 cm.*

in the so-called Six States (Ch'i, Ch'u, Yen, Wei, Han, and Chao). The other is the *daiten,* or greater seal, script (Fig. 4), established in the state of Ch'in.

There was in each period a script in common use by the Chinese, as well as supplementary scripts for special purposes. One example of a standard script is *shoten* (lesser seal; Fig. 5), established by Li Ssu (d. 210 B.C.), prime minister under Shih Huang-ti of Ch'in, the so-called First Emperor. By the time of Shih Huang-ti, regional variants of many characters of the greater seal script had appeared and the standardization of this script by Li Ssu resulting in the lesser seal script was undertaken as part of the general policy of standardization in the Ch'in period.

Other standard scripts are: *korei* (old *reisho;* Fig. 6), a simplification of the lesser seal style by Ch'eng Mo of Ch'in to relieve the drudgery of official duties; and *happun* (the so-called *kanrei;* Fig. 7),

a beautiful variation of the *korei* created in the Han dynasty (206 B.C.–A.D. 220).

Some examples of the supplementary scripts, ones limited to special applications, are *kokufu,* used for tally inscriptions; *chusho,* or "serpent writing," for banners; and *shusho,* or "lance writing," for weapon inscriptions.

The five styles now considered to be the basic calligraphic styles—that is, *tensho* (seal style), *reisho* (scribe's style), *kaisho* (block, or standard, style), *gyosho* (semicursive, or running, style), and *sosho* (cursive style)—had all appeared before the end of the fourth century. The oldest of these is *tensho,* which includes the greater and lesser seal styles.

We know from the preface of the *Shuo Wen Chieh Tzu* that *sosho* (literally, "grass writing") was a recognized script in the Han period. In connection with writing, the word *so* (literally, "grass") originally had the sense of "rough draft," and it is

8. Kaisho *by Wang Hsi-chih* (Yueh I Lun). A.D. *384.*
Copybook; height, 29.5 cm.

thought that in the Chou period, when *tensho* was in use, a simplified version of *tensho* existed for note-taking purposes. And in fact there are examples of modern *sosho* characters (like *mu,* "non-existence" that are cursivized *tensho.* The inscriptions on wooden strips from the Former Han dynasty (206 B.C.–A.D. 8) prove that a *sosho* type of script called *koso* ("old grass"; Fig. 10) was then in use. Another form of *sosho* is *shoso* (Fig. 9), which developed from *koso.* This is distinguished by a vigorous undulating brushwork known as *hataku,* or "waves breaking," in which strokes bounce upward sharply to the right, accompanied by extreme variations of line width. It was a long-recognized style among calligraphers. Later, abandoning *hataku* brushwork, *sosho* developed into the unconnected *doku-sotai* (Fig. 17) and connected *remmentai* (Fig. 19) styles, and in the T'ang dynasty (618–907) the "wild grass" style (*kyoso;* Fig. 20) appeared.

Another basic style, *gyosho* (running, or semi-cursive), was also in use during the Han period, and it is thought to have been created by Liu Te-sheng of the Later Han (A.D. 25–220). Later, in the *Li Shu Shih* by Wei Heng of Wei (220–64), we find a passage that states, "The two calligraphers Chung and Hu used *gyosho* at the beginning of the Wei dynasty. They studied with Liu Te-sheng. Although Chung's *gyosho* is a little unusual, both are skillful. They say *gyosho* is very popular at present." According to this work, *gyosho* is a simplification of *reisho,* and is thought to have appeared as a distinct style during the transition from the Later Han to the Wei dynasty. Typical examples of *gyosho* can be seen in *Ta T'ang San Tsang Sheng Chiao Hsu* (Fig. 18), a collection of the calligraphy of Wang Hsi-chih of Chin (265–420). The exact dates of Wang Hsi-chih's birth and death are not known, but they are usually given as 321–79. Although born into a good family, his official career was not entirely successful. His reputation as a

THE DEVELOPMENT OF CHINESE AND JAPANESE SCRIPTS

Japanese and Chinese pronunciations of characters are preceded by the abbreviations "J." and "Ch." respectively.

With the exception of the ornamental scripts, dates given in this chart indicate the approximate time when the scripts became established as distinct writing styles.

ORACLE-BONE AND TORTOISE-SHELL INSCRIPTIONS
甲骨文, J. *kokotsubun*, Ch. *chia ku wen*.
Yin period (c.1500–1100 B.C.)

BRONZE-VESSEL AND BELL INSCRIPTIONS
鐘鼎文, J. *shoteibun*, Ch. *chung ting wen*.
Chou period (c.1100–221 B.C.)

SEAL SCRIPT
篆書, J. *tensho*, Ch. *chuan shu*[1]

GREATER SEAL SCRIPT
大篆, J. *daiten*, Ch. *ta chuan*.
Used in the state of Ch'in.
Warring States period (403–221 B.C.)

LESSER SEAL SCRIPT
小篆, J. *shoten*, Ch. *hsiao chuan*.
Traditionally said to have been invented
by Li Ssu (d. 210 B.C.)
Ch'in period (221–206 B.C.)

SCRIBE'S SCRIPT
隸書, J. *reisho*, Ch. *li shu*[2]

OLD REISHO
古隸, J. *korei*, Ch. *ku li*. Traditionally said
to have been invented by Ch'eng Mo.
Ch'in period (221–206 B.C.)

HAN REISHO
漢隸, J. *kanrei*, Ch. *han li*.
Also called *happun* (八分, Ch. *pa fen*).
Han period (206 B.C.–A.D. 220).

ORNAMENTAL SCRIPTS
雑体書, J. *zattaisho*, Ch. *tsa t'i shu*; including
hihaku (飛白, Ch. *fei po*). Mainly variants of
tensho and *reisho*. Popular about the fifth
and sixth centuries A.D.

BLOCK SCRIPT
楷書, J. *kaisho*, Ch. *k'ai shu*.
About fourth and fifth centuries A.D.

[1] The term *tensho* in its wider sense refers to both *daiten* and *shoten*, but it is often used to refer to *shoten* only.

[2] The term *reisho* in its wider sense refers to both *korei* and *kanrei*, but it is often used to refer to *kanrei* only.

[3] A cursive form of *tensho* is thought to have been in use, although no examples of such a script from this period have been found.

[4] The term *sosho* generally refers to the *dokusotai*, *remmentai*, and *kyosotai* forms, but it is also used to include *koso* and *shoso*.

CURSIVE FORM OF TENSHO
Warring States period (403–221 B.C.)[3]

ANCIENT SCRIPT
古文, J. *kobun*, Ch. *ku wen*.
Used in the Six States.
Warring States period (403–221 B.C.)

CURSIVE SCRIPTS
草書, J. *sosho*, Ch. *ts'ao shu*[4]

OLD SOSHO
古草, J. *koso*, Ch. *ku ts'ao*.
Former Han period (206 B.C.–A.D. 8).

SHOSO
章草, Ch. *chang ts'ao*.
Later Han period (25–220).

UNCONNECTED SOSHO	CONNECTED SOSHO	WILD SOSHO
独草体, J. *dokusotai*, Ch. *tu ts'ao t'i*. About fourth century A.D.	連綿体, J. *remmentai*, Ch. *lien mien t'i*. About fourth century A.D.	狂草体, J. *kyosotai*, Ch. *k'uang ts'ao t'i*. T'ang period (618–907).

SEMICURSIVE SCRIPT
行書, J. *gyosho*, Ch. *hsing shu*.
Han period (206 B.C.–A.D. 220).

DEVELOPMENTS IN JAPAN

MAN'YO-GANA 万葉仮名
Fifth to tenth centuries A.D.

MEN'S HAND
男手, *onokode*. *Kanji* used phonetically:
kaisho gyosho

SO KANA 草仮名
Kanji used phonetically:
sosho

KANA SYLLABARIES
Heian period (794–1185).

KATAKANA 片仮名

HIRAGANA 平仮名
(=女手, *onnade*, or women's hand).

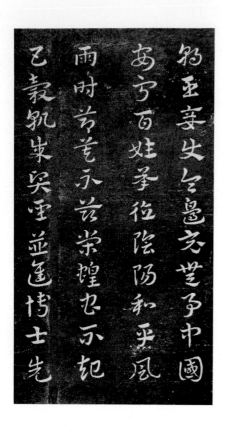

9 (left). Shoso. *Third century* A.D. *Copybook; 25.2 × 12.9 cm.*

10 (right). Koso (old sosho). *Wooden strip dated 62* B.C.; *19.3 × 1.1 cm.*

calligrapher, however, is unequaled. He played an important part in bringing the *kaisho, gyosho,* and *sosho* scripts to their present high level of artistic excellence. Although he wrote in all three scripts, his *gyosho* and *sosho* are particularly famed. His son Wang Hsien-chih (344–88) also made important contributions to calligraphy, and the two together are known as "the two Wangs."

I have already mentioned that *korei* (old *reisho*) was a simplification of *shoten* (lesser seal) and that *kanrei* (Han *reisho*) was a variation of *korei*. The process by which the *kanrei* style was gradually simplified and developed into *kaisho* is evidenced by stone inscriptions and autographs dating from around the Three Kingdoms (220–65) and Western Chin (265–317) periods. Of the recently discovered monument and tomb inscriptions, ranging from the Eastern Chin (317–420) to the Liu Sung

(420–79) and Ch'i (479–502) dynasties, some of the Eastern Chin examples still show elements of *kanrei* style. In general, however, the script had become *kaisho* (block writing) or a style close to it. From various sources we can infer that the *kaisho* style practiced today was developed in the Eastern Chin and Liu Sung periods.

The Eastern Chin dynasty was established in 317 with its capital in the city now known as Nanking, on the Yangtze River. The fresh culture of the region south of the Yangtze was flourishing, and calligraphy made rapid strides, producing many outstanding calligraphers like Wang Hsi-chih and his son Wang Hsien-chih. During this period the five scripts were polished and were established as mature calligraphic styles.

Around the fifth and six centuries, in addition to the main styles, yet another category, *zattaisho*,

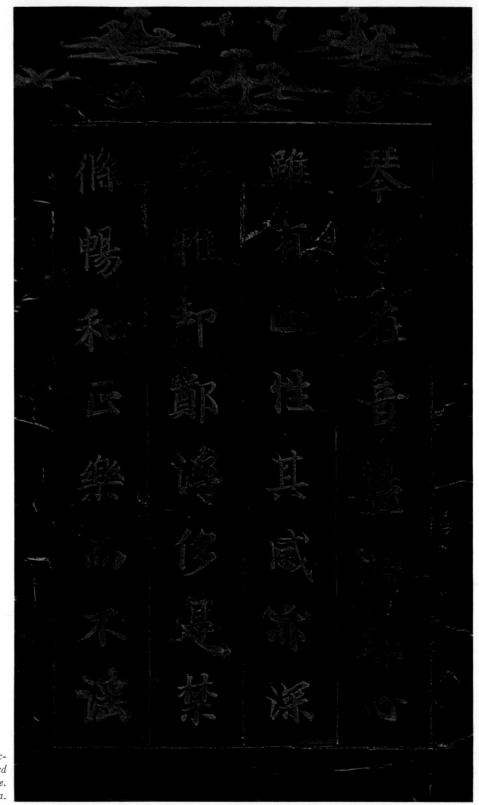

11. Inscription on koto. Lacquered wood; characters incised and filled in with silver paste. Eighth century. Shoso-in, Nara.

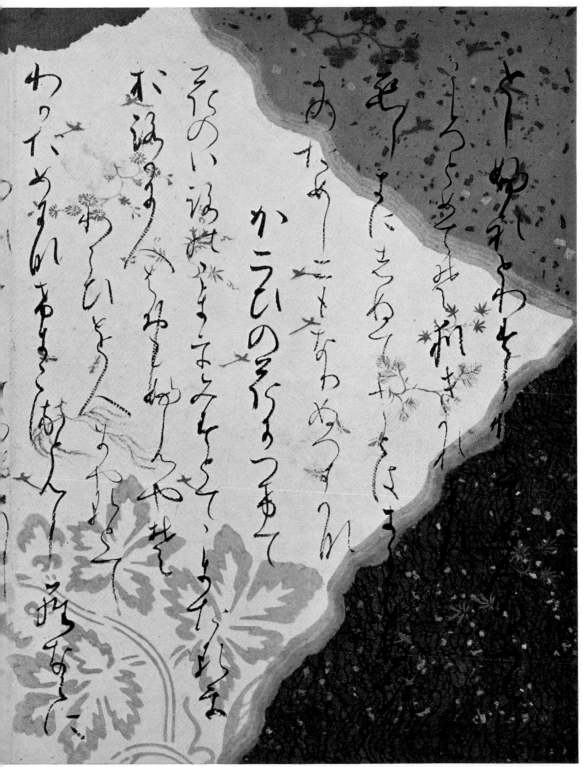

12. Ishiyama-gire *(mounted segment of* Ise-shu *section of Nishi Hongan-ji manuscript of* Sanjuroku-nin Shu, *an anthology of* waka *by the so-called thirty-six poetic geniuses). Early twelfth century.* Tsugigami *"patched paper," originally* detcho *glued binding; 20.2 × 31.8 cm. Collection of Hikotaro Umezawa, Tokyo.*

14. *Section of* waka *scroll. Calligraphy by Hon'ami Koetsu, on paper decorated in gold and silver by Tawaraya Sotatsu; 33.7×
924.1 cm. Early seventeenth century. Hatakeyama Museum, Tokyo.*

◁ 13. *Two panels of* Torige Tensho Byobu. *Sixfold screen; each panel 149 × 56 cm.; text in feather-*tensho *and* reisho *on paper.
Eighth century. Shoso-in, Nara. (See Fig. 23 for entire screen.)*

老帶之□好遺在護筒追處耀

然謹以奉獻

盧舍那仏伏顚以此妙善奉翼

冥途高遊方廣之通衢恒演

圓伊之妙理

天平寶字二年六月一日

紫微内相從二位兼行中衛大將近江守藤原朝臣

15. *Section of* Daisho O Shinseki Cho, *a list of autograph calligraphies of Wang Hsi-chih and his son Wang Hsien-chih. Dated 758. Colored-paper scroll; 24.4 × 87 cm. Part of the* Todai-ji Kemmotsu Cho, *a catalogue of donations to Todai-ji. Shoso-in, Nara.*

17. Unconnected sosho (dokusotai) *by Wang Hsi-chih. Fourth century* A.D. *Copybook; height, 25 cm.*

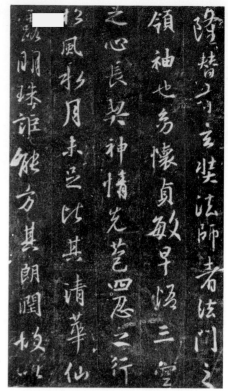

18. Gyosho *by Wang Hsi-chih (from* Ta T'ang San Tsang Sheng Chiao Hsu; *compiled 672). Ink rubbing; 27.5 × 15 cm.*

or ornamental scripts (literally, "miscellaneous scripts") came into fashion. This category contains chiefly variant forms of *tensho* and *reisho*. Orthodox styles are sometimes mixed among them. Often they appear to have been done in both black ink and color on folding screens for decorative use in palaces. We can imagine how breath-takingly beautiful they must have been. Examples of this are found in the thirty-six kinds of old scripts presented in the *Wen Tzu Chih* by Wang Yin of Liu Sung and the forty-three kinds in the *Chuan Li Wen T'i* by Hsiao Tzu-liang of Ch'i (Fig. 21 and foldout following page 72). Sou Yuan-wei of Liang mentions in the *Lun Shu* a tenfold screen inscribed with one hundred script styles, fifty in color and fifty in black ink. The ornamental styles

were in use until about the T'ang dynasty, but fell into disuse from the Sung period (960–1126) onward.

KANA Japanese styles of calligraphy are equivalent to the basic Chinese styles I have been discussing. During the transmission from China, however, important modifications occurred, and of interest is the way in which the styles were accepted and the manner in which their evolution continued in Japanese hands.

In addition to the five basic scripts of Chinese calligraphy, the Japanese developed *kana*, characters that express sounds in contrast to characters used ideographically. Three types of *kana* have been developed, *man'yo-gana*, *hiragana*, and *katakana*.

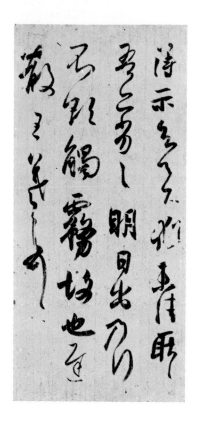

Man'yo-gana are certain *kanji* used phonetically to represent the syllables of Japanese, and are so named after the eighth-century poetry collection *Man'yoshu,* because this method is used a great deal in the anthology. At the time this collection was compiled, the Japanese had no writing system of their own, so that some of the Japanese poems in it are rendered in Chinese characters that are used phonetically, and in others the Chinese characters are used sometimes phonetically and sometimes ideographically. Out of this kind of phonetic usage, and by way of drastic simplification, the two syllabaries of *hiragana* and *katakana* evolved. At first *katakana* were used in combination with *kanji* to denote verb endings while *hiragana* were used independently. Later *hiragana* too came to be used in combination with *kanji*. In present-day usage, however, it is *hiragana* that are primarily used with *kanji* while *katakana* serve chiefly for such special uses as emphasis, telegrams, and foreign loanwords. *Man'yo-gana* are no longer used except in calligraphy.

Kana can also be considered from the point of view of three styles: men's writing (*onokode*), women's writing (*onnade*), and grass writing (*so*). Men's writing refers to characters in the *kaisho* and *gyosho* scripts used phonetically, while *so* refers to the cursive *sosho* script used phonetically. Women's writing is *hiragana*. *Kaisho, gyosho,* and *sosho* are of course Chinese script styles but what was said about them in the context of Chinese calligraphy applies in principle to their use as *man'yo-gana* in Japan. An exception is the sex distinction just mentioned. Chinese studies came to be regarded as the special

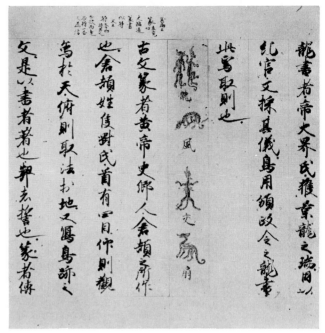

◁ 19 (*opposite page, left*). *Connected* sosho (remmentai) *by Wang Hsi-chih. Fourth century* A.D. *Paper; height, 28.7 cm. Imperial Household Collection.*

◁ 20 (*opposite page, right*). *"Wild"* sosho (kyosotai) *by Huai Su; 777. Paper scroll.*

21. *"Dragon writing," from Hsiao Tzu-liang's* Chuan Li Wen T'i. *Bishamon-do, Kyoto.*

field of men, and women were restricted to the use of *hiragana*. In the hands of the Japanese noblewomen, *hiragana* developed by the greatest possible simplification and refinement of *sosho*. This beautiful script can justly be called the unique calligraphic style of Japan.

The other Japanese syllabary, *katakana*, developed from the diacritical marks used by Japanese men as aids to reading Chinese texts. And though *katakana* is in some respects of practical significance, its range of application is narrow and it need not be considered here as an important style.

An interesting application of *hiragana* is as an ornamental device. In Japan ornamental characters corresponding to the *zattaisho* ornamental scripts of Chinese calligraphy are preserved on wooden plaques or signboards that carry the names of buildings, gates, ponds, etc. For the most part the origins of these applications are to be found in China. The *uta-e* (literally, "poem picture") is a version of the type of landscape painting known as *ashide* (literally, "reed hand") and is a purely Japanese ornamental use of characters. Typically this kind of picture would consist of a riverside or lakeside scene showing reeds, and would have a text some of whose characters, written so as to resemble reeds, are partly hidden in the reeds. Later, characters were written and positioned so as to suggest not only reeds but also flowing water, waterfowl, banks, rocks, etc. This type of calligraphy is rather different in character from the Chinese *zattaisho*. The presence of the element of nature makes it something special, unknown in China.

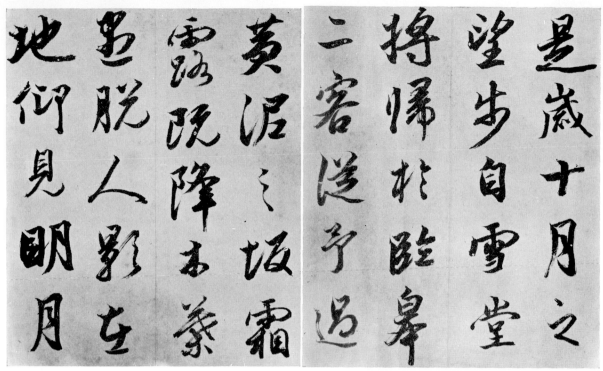

22. Section of Hou Ch'ih Pi Fu *(poem by Su Tung-p'o). Calligraphy by Nukina Kaioku; 1855. Paper; 28.5 × 23.3 cm.*

The many styles of Chinese characters show a great deal of variety; in contrast, *hiragana* is simple yet beautiful. And Japanese calligraphy shows itself most characteristically in *hiragana*. It was originally an offshoot of *sosho*, and for this reason we may say that Japanese calligraphy is most closely related to the grass style. This relationship is also shown in the varying degrees of Japanese facility with different styles of *kanji*, for it is generally recognized that of the five basic styles the Japanese are weak in *tensho* and *reisho* but good in *gyosho* and *sosho*. This seems to stem from the essence of Japanese calligraphy; that is, even in *kanji* the grass style best expresses the nature of Japanese calligraphy. Thus it is most appropriate to regard the essence of Japanese calligraphy as the art of *sosho*.

In the following chapters, we will take up Japanese calligraphy by script styles, examining each in more detail, and enlarging upon the theories touched on here.

CHAPTER TWO

Tensho: Seal Script

EARLY TENSHO IN JAPAN As I mentioned earlier, a *tensho* script was in common use during the Chou and Ch'in periods in China. Later on it was no longer ordinarily used, but became instead a special-purpose calligraphic style. For example, from the Han period on, titles called *tengaku*, or *tensho* plaques, on stone monuments were often inscribed in *tensho*. Curiously, even though the title of the inscription on the *tengaku* may be in *tensho*, the body is in *reisho*. (See Figs. 64, 65.) The classic and graphic nature of *tensho* is well suited for writing titles, and its use as such is now a long-established custom.

Since Chinese characters were introduced into Japan much later than the Chou and Ch'in periods, *tensho* never figured as a common script there. Probably the earliest record of *tensho* in Japan is the gold seal (Fig. 24) bestowed on the king of Kan-no-Wa-no-Na, a small independent region of northern Kyushu, by the Chinese emperor Kuang Wu in A.D. 57. It was discovered at the bottom of a stone chamber in Shikanoshima, Fukuoka Prefecture, in 1784, and even then attracted the interest of many antiquarians. Detailed studies have been made of it and it has been often copied. The script style used for this seal resembles *byuten* or *moin*, Han-period *tensho* variants whose use is restricted to seals of the period. This gold seal should be regarded as having been made in China and, consequently, its existence is not evidence that *tensho* was used in ancient Japan.

In Japan we first come across the *tensho* style in an extraordinary work from the Nara period (646–794). The sixfold feathered folding screen known as *Torige Tensho Byobu* (Figs. 13, 23) in the Shoso-in Repository, a storehouse of Emperor Shomu's relics, is a splendid example of this style. It is one of the hundred screens and other objects bequeathed by Emperor Shomu to Todai-ji temple in 756, and is listed in the Catalogue of National Treasures (*Kokka Chimpo Cho;* Fig. 85), one of Todai-ji's catalogues of donations. Fortunately this screen, together with another sixfold screen known as *Torige Josei Bunsho Byobu* and bearing an inscription in block *kaisho* (Fig. 163), is preserved at the Shoso-in. Everything about the *Torige Tensho Byobu*—calligraphy, paper, and fittings—is beautiful. The paper has been prepared by blowing green and brown pigments onto it in such a way that bird and flower motifs are formed. Upon this background, *tensho* and *reisho* characters are alternately inscribed—that is, each *tensho* character is followed underneath by its *reisho* equivalent. There are eight characters in each column and two columns on each panel of the screen. The inscription advises the ruler to conduct righteous government through wise ministers, and for this reason it is classified with the so-called ruler-minister screens. The *tensho* style used is an ornamental variety, one of the *zattaisho*. The characters are outlined with pieces of black feather and filled in with gold leaf. The *reisho* is actually a kind of

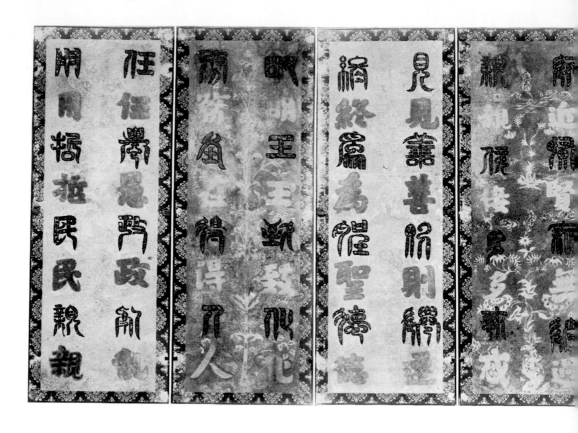

archaic *kaisho* style, and the pigment used for it has been blown onto the green background, causing it to float up in relief. Scattered spots of vermilion further decorate the screen.

There are two other "feather" screens at the Shoso-in: one panel of the *Torige Josei Byobu* and one that is called by the same name as the screen we have been discussing: *Torige Tensho Byobu*. The *Torige Josei Byobu* is in block *kaisho*; unfortunately it has peeled badly. The *Torige Tensho Byobu*, like the one with the same name, has its inscription alternately in *tensho* and *reisho*. This one, however, consists of only a single panel bearing two columns: *tensho* and *reisho* versions of a four-character inscription. The paint of the *tensho* column has peeled badly, but it appears to have been done in a

zattaisho type of *tensho*. Perhaps this single panel represents the remains of a screen listed in Todaiji's catalogue of donations as a "sixfold bird-script screen" originally in the Shoso-in.

In China, these *zattaisho*-script screens can be traced as far back as the Six Dynasties period (A.D. 222–589). In the *Lun Shu*, Sou Yuan-wei of Liang (502–57) reports that the magnificence of a tenfold screen inscribed with a hundred different script styles astounded the people of the time. The first fifty scripts were in black ink, while the remaining fifty were colored. The scripts used were *zattaisho* styles with names like needle script, dripping-dew script, gazing-to-Chin script, drawing-well-water-on-a-hill script, gold-mixed script, etc. Actual examples of these styles can be seen in the

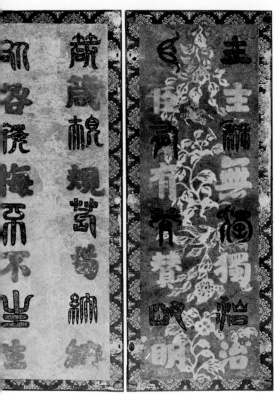

23. Torige Tensho Byobu. *Sixfold screen, each panel 149 × 56 cm.; text in feather-*tensho *and* reisho *on paper. Eighth century. Shoso-in, Nara. (See also Fig. 13.)*

Chuan Li Wen T'i (Fig. 21 and foldout following page 72) compiled by Hsiao Tzu-liang of the Ch'i dynasty (479–502). There are also extant *soshu* screens said to be by Emperor T'ai Tsung of the T'ang dynasty (618–907). And there is a record in the *Ku Chi Chi* by Hsu Hao of the T'ang dynasty that states that in the reign of Chung Tsung of T'ang, the official Tsung Ch'u-k'e presented the emperor with some calligraphy by the two Wangs that was used in a twelvefold screen. The *Hsien Ch'ing Fu* and *K'u Shu Fu,* written by Ch'u Chu-liang, were used for the lower part of the screen. We can imagine that in the beginning of Hsuan Tsung's reign, at the magnificent height of T'ang culture, the screens used in the court must have been superb. In eighth-century Japan, when T'ang

culture was just being introduced, this sumptuous style of furnishing from the T'ang court was carried over. In fact, among the hundred folding screens in the Shoso-in there are six panels of a screen called *Relaxing in Front of the Great Ch'in Cheng Pavilion* by Ch'ien Ch'iu-chieh which, historically speaking, must have been painted after 729. We can speculate from these examples that the hundred screens of the Shoso-in are a reflection of the luxurious T'ang culture at the time of Emperor Hsuan Tsung.

Old seals are another medium that preserves examples of Nara- and Heian-period *tensho*. In ancient China, letters and documents were bound with a cord and the closure was sealed by attaching a piece of soft clay. Before it hardened the clay

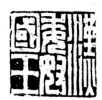

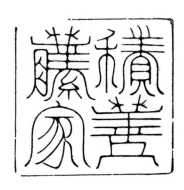

24. *(Above) gold seal of the king of Kan-no-Wa-no-Na; (below, left) imprint of seal; (below, right) engraved surface of seal. About* A.D. *57.*

25. Yamato koin *(old seal). Eighth century. Actual size. (See also Fig. 35.)*

was marked with an impression of some distinguishing device, usually an inscription of one or more characters. From about the end of the Six Dynasties period (222–589), the impression was made directly on the paper, using ink applied to the inscribed surface of the seal. The functions of such seals were many: to indicate that a document issued from an official agency, to indicate assent to the content, etc. In the case of calligraphies and paintings, seals bearing the name or soubriquet of the user were used in lieu of signatures, to indicate ownership, to indicate an expert's certification of the authorship of a work, etc. The custom of using seals was introduced into Japan in the Asuka period.

The ink used for seal impressions was made from cinnabar (a compound of mercury) and the contrast of the splash of vermilion of the seal and

the deep black of the characters added a further dimension to the beauty of calligraphy. Eventually calligraphers started using additional seals inscribed with mottoes or elegant phrases. Ultimately, with the literati of the Ming period, the seals became an end in themselves, and folios of seal imprints were made for appreciation by connoisseurs.

The materials used for the seals themselves are very varied. Cast metal seals in brass, silver, or gold, and engraved seals in brass or jade, could only be made by specialist craftsmen, but other materials—like ivory, bone, wood, bamboo roots, and stone—were more easily workable. Seals were also made in porcelain. In the Ming period, stone suitable for seal engraving, especially alabaster, became readily available, and this gave a strong impetus to the growing popularity of seal carving

26. *Detail of* Hakurakuten Shiku *(Poems of Po Chu-i), by Emperor Daigo. Early tenth century. Paper scroll; 32 × 179.2 cm.* ▷
Imperial Household Collection. (See also Fig. 117.)

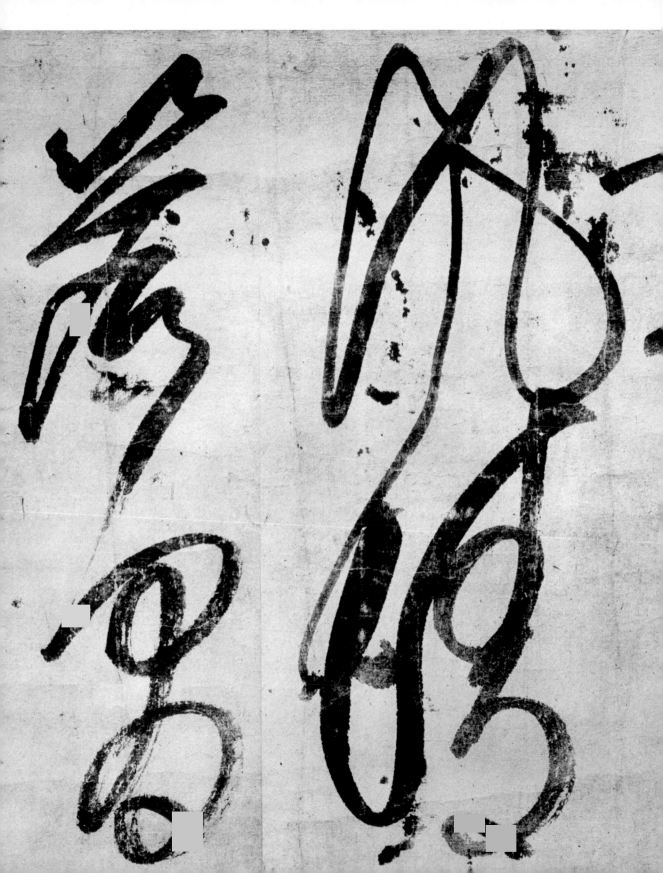

勅意數七道諸國簡擇

若以精勤少欲知足者

置若内候奉割正税稻

以給資粮无有所之者

僧圓孫合亮件選若大

27. *Section of* Naigubu ni Atsuru no Chibusho Cho. *Paper scroll; 850. Height, 29 cm.; length, 139 cm. Tokyo National Museum.*

29. Rikyo Hyakuei Dankan, *attributed to Emperor Saga. Fragment of anthology of poetry by Li Chiao, a T'ang poet. Early ninth century. Paper; 26.1 × 13 cm. Yomei Bunko Library, Kyoto.*

30. *Section of Kojokaicho, by Emperor* ▷ *Saga; 823. Paper scroll; 36.9 × 148.1 cm. Enryaku-ji, Shiga Prefecture.*

受菩薩戒弟子□□稽首和南　衆□□下

竊以無明長夜戒光為炬燼

後軌範末又為師師以賊

傳以立肜整於之遊免食
　　　　　　草

沙門顗鵝珠お□死後故

能三觀偈乘結三身於究

竟三種戒開三目於

初發但見□□之當目□

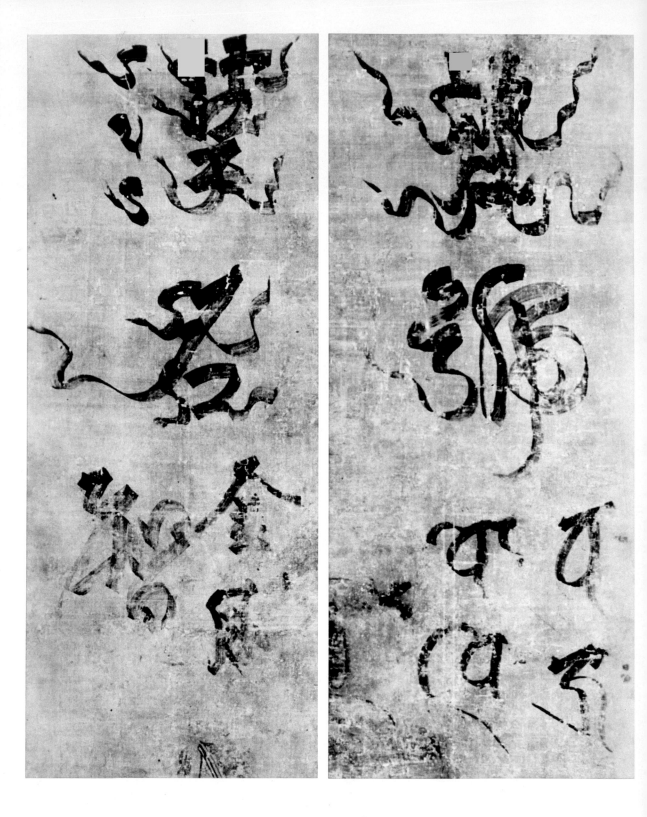

急救拒君乞銷陶尓
御香雨暴及左衞士
精尊書状芝詫領
乾迫以法僚楷關諫
披過此法期披雲
因夕速信奉此而身
桁遍照状上
　　　　十二日

32. *Section of letter in* Fushinjo *(collection of three letters written by Kukai). About 812. Paper scroll; height, 28.5 cm. Kyo-o-gokoku-ji (popularly known as To-ji), Kyoto.*

◁ 31. Hihaku *inscription by Kukai on portrait of Kongochi, one of the patriarchs of the Shingon sect. Early ninth century. Silk; overall size, 212.7 × 150.9 cm. Kyo-o-gokoku-ji (popularly known as To-ji), Kyoto.*

久隔清音馳系無極傳承

安和且慰下情

大阿闍梨所示五八詩序中有

一百廿禮佛并方圓圖并注義

華名今奉和得本知其礼

仍當志伏乞今聞阿闍梨

其所樣當義並其大意者

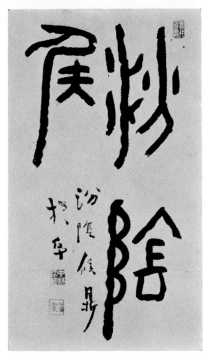

34. Study by Gochiku Nakabayashi of
bronze-vessel inscription. Late nineteenth to
early twentieth century. Paper.

as an independent artistic activity, since the material could be easily worked by amateurs. Great care and ingenuity were expended on some seals, the grip part of the seal being cast or carved into highly decorative forms. (See Fig. 24.)

Seals from the Nara and Heian periods are numerous, and public seals range from the *Tenno Gyoji*, or Seal of the Interior (Fig. 46), and *Dajokan*, or Seal of the Exterior, to the various ministerial seals, and seals of the provinces, counties, villages, shrines, and temples. There were also clan and personal name seals for private use. These old seals are collectively called *Yamato koin* (Fig. 35) and are treasured by collectors. It appears that official seals were widely used in the Nara period,

the custom having been introduced from the continent at the time the legal framework was established. The use of private seals, however, seems not to have been so widespread.

Properly speaking, *tensho* should be used on seals, and the style is usually the lesser seal script, *shoten*. There seem to have been people in Japan at the time who could write in the *shoten* style, but by the Heian period the use of *tensho* for seal inscriptions seems to have decreased in favor of *kaisho*. Presumably this was because the easy-to-write and easy-to-read *kaisho* script was more suited to Japan. Furthermore, because of the simplicity of style, these old *kaisho* seals are often prized by collectors.

◁ *33. Section from letter in* Kyukaku Jo, *by Saicho; 813. Paper; 28.2 × 52.2 cm. Nara National Museum.*

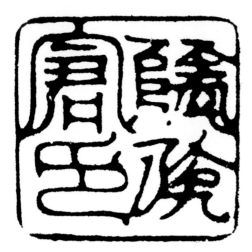

35. Yamato koin *(old seal). Eighth century. Actual size. (See also Fig. 25.)*

We can pass from the Nara through the Heian period without seeing much significant development of *tensho* seals. Finally though, in the Kamakura (1185–1336) and Muromachi (1336–1568) periods, the seal-carving (*tenkoku*) style of the Sung and Yuan dynasties in China was brought over, and in the Edo period (1603–1868), *tenkoku* as it is known today was developed by priests of the Obaku sect of Zen Buddhism and by immigrants in Nagasaki. With this development, for the first time, the *tensho* script became established in Japan.

The Buddhist priest Kukai, often referred to by the posthumous title Kobo Daishi, is a man of vast importance not only in Japanese religion but also in the field of calligraphy—he was one of the *sampitsu,* or three outstanding calligraphers of the early Heian period. Born in 774 in the province of Sanuki on the island of Shikoku, he crossed to the main island of Honshu at the age of fifteen, and studied avidly in Nara. He took his final vows at Todai-ji at the age of twenty-two. In 804 he went to China, where he studied esoteric Buddhism

under Hui Kuo, and returned to Japan in 806, bringing much Chinese calligraphic material with him. Three years later he started propagating esoteric doctrines and in 816 he established Kongobu-ji on Mount Koya, becoming the first patriarch of the Shingon sect. Kukai died in 835. One of the books brought back by him is the abovementioned *Chuan Li Wen T'i.* Kukai is also the author of *Tenrei Bansho Meigi,* a six-volume dictionary of *tensho* and *reisho* that is the oldest extant character dictionary compiled in Japan. His *Masuda no Ike no Himei* (Fig. 68) is the text of a pillar inscription written in each basic style as well as in *zattaisho* and includes several varieties of *tensho.* Today, however, the major part of surviving calligraphy attributed to him is in *kaisho, gyosho,* and *sosho* styles. Examples of his decorative *hihaku* style (Fig. 69) and other *zattaisho* arc also to be found, but virtually no "proper" *tensho* by Kukai is extant. His work is discussed at greater length in Chapter Four.

In the Heian period, when the Japanese style of calligraphy arose, calligraphy in the Chinese tradition no longer prospered, and inevitably the development of the *tensho* style was cut short. In the final analysis, we can say that aside from the examples introduced here (Figs. 38, 68), Heianperiod *tensho* is practically nonexistent.

In the Kamakura period there were some outstanding calligraphers among Japanese Zen priests who had studied in Sung China and also among naturalized priests of Chinese origin. However, these men were out of the mainstream of calligraphy and were basically not much concerned with technique. There were, consequently, practically no Kamakura calligraphers who wrote in the *tensho* and *reisho* styles even for the sake of variety of script style.

EDO- AND MEIJI- PERIOD TENSHO *Tensho* became popular in Japan after the arrival of priests of the Obaku Zen sect in the Edo period. In 1653 Dokuryu (in Chinese, Tu Li) came to Japan and later became an Obaku priest under Ingen (in Chinese, Yin Yuan), the founder of Mampuku-ji temple. Although he was primarily

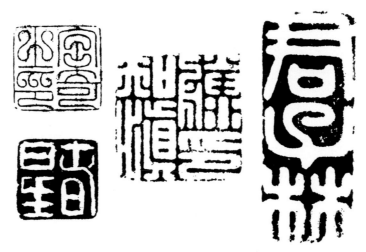

36. Tensho *seals. Left, top and bottom: two seals by Ko Fuyo, eighteenth century. Center and right: two seals by Hosoi Kotaku, seventeenth to eighteenth century. Actual size.*

a calligrapher, he was also well trained in seal carving and was the first to introduce its techniques into Japan. Dokuryu had a thorough knowledge of characters and in his work *Shibun Taihon* (in Chinese, *Ssu Wen Ta Pen*) stressed that the *Shuo Wen Chieh Tzu* was to be considered the fundamental authority on characters. He himself wrote principally in *sosho,* although some *tensho* is also to be seen in his work.

Shin'etsu (in Chinese, Hsin Yueh; 1640–96) arrived in Japan in 1677, twenty-four years after Dokuryu. A high-ranking priest of the Soto sect of Zen, he was invited by Tokugawa Mitsukuni,[3] daimyo of Mito, to become the first abbot of Gion-ji on Mount Jusho in Mito. The tradition founded by him later came to be known as the

"Shin'etsu Branch" of Soto. In addition to being a talented poet, musician, and painter, Shin'etsu was a skillful seal carver, and together with Dokuryu is considered to be the founder of seal carving in Japan. His *tensho* can be seen on plaques at Gion-ji. When he came to Japan he brought rare Chinese *impu* (collections of seal impressions) and *tensho* dictionaries, and the spread of these materials made a large contribution to Japanese seal carving. Among the *tensho* dictionaries he brought is *Yun Fu Ku Chuan Hui Hsuan,* published by Ch'en Ts'e of Ch'ing (1644–1912). This dictionary arranged various old styles of *tensho* by the four tones of the Chinese language. It was a real treasure in an age when there were very few *tensho* dictionaries. The blocks for this book were carved in 1713 at the Ryushiken in Kyoto, and published at the Shoko-kan, established by Tokugawa Mitsukuni. After seal carving was introduced by Dokuryu and Shin'etsu, the art became fashionable in Edo (present Tokyo). At the same time many people who engaged in this activity undertook the study of

[3] The names of all premodern Japanese in this book, where they consist of a family name and a personal name, are given in Japanese order (family name first); those of all modern (post-1868) Japanese are given in Western order (family name last).

37. Tensho *by Ko Fuyo. One panel of folding screen formerly in the Kimura Kenkado collection. Eighteenth century.*

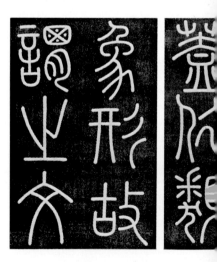

38. *Fragment of the* Thousand Character Essay *in* tensho *and* reisho, *attributed to Ono no Michikaze. About tenth to eleventh century. Paper; 24.1 × 36 cm. Imperial Household Collection.*

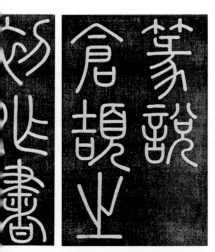

39. Tensho *from* Tensetsu, *by Sawada Toko. Published 1780.*

40. Tensho *by Yamanashi Tosen ("Lan T'ing Hsu"). Paper; 1824.*

41. Two pages from Itto Bansho, *by Ikenaga Doun. Published 1713.*

tensho and many of them became quite skilled. Hosoi Kotaku (1658–1735), a student of Kitajima Setsuzan, was the best known calligrapher of the day in the Chinese tradition. Known as a Confucian scholar, he was originally a physician. He wrote *waka* poetry, painted well, and was also an accomplished archer. Kotaku was a good seal carver and wrote *tensho* as well. The Mangan-ji in Tokyo is his family temple, and the characters "Chi Ko Zan" written by him on the plaque at the gate of the temple show a free and powerful brushwork. Kotaku compiled *Tentai Ido no Uta,* a work based on a book of the same name (in Chinese read *Chuan T'i I T'ung Ke*) by Ying Tsai of the Yuan dynasty (1279–1368). It clarifies the differences between easily confused *tensho* charac-

ters. At a later date it was published in a single volume together with Ikenaga Doun's *Tenzui Furoku.*

In addition to Kotaku, Dokuryu's pupil Ko Gentai and the above-mentioned Ikenaga Doun (1674–1737), famous as a seal carver and as the author of the pioneering collection of seal imprints *Itto Bansho,* were also skillful *tensho* writers (Fig. 42). Mitsui Shinna (1703–82), a student of Hosoi Kotaku and also known as an exponent of the martial arts, was another calligrapher who wrote fine *tensho* and *reisho.* At one time, when ornamental *tensho* and *reisho* styles were the fashion in Edo, cloth dyed with his characters was in great demand under the name Shinna-*zome.*

The first names that come to mind as models

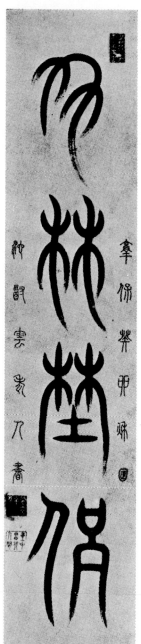

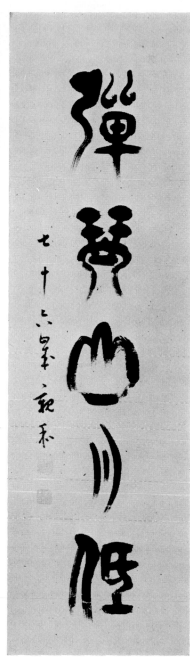

42 (far left). Tensho by Ikenaga Doun; 1723.

43 (left). Tensho by Mitsui Shinna. 1775. Paper; 100 × 28.2 cm.

44. Tensho by Itsuzan. Eighteenth century. Paper; 131.5 × 14 cm.

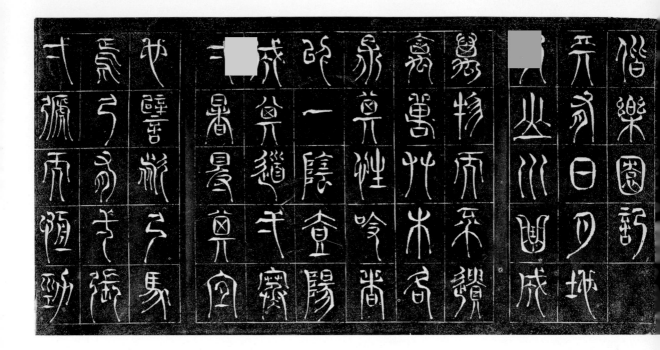

of *tensho* in China are Li Ssu, Prime Minister of Ch'in (221–200 B.C.), and Li Yang-ping of T'ang (618–907). We know from contemporary catalogues that *tensho* in the form of printed editions of Li Ssu's *I Shan Pei* inscription and Li Yang-ping's monument inscriptions were circulated in Edo-period Japan. The famous *karayo* calligrapher and seal carver Sawada Toko (1732–96) is the author of *Tensetsu* (Fig. 39), a book written in *tensho* and expressing the view that Li Ssu and Li Yang-ping should be the basic models for *tensho*. Toko's students carved the treatise on wooden blocks and white-on-black copies were taken from it. Matsushita Useki was another well-known calligrapher who had a flair for seal carving. In 1737 he revised the Japanese edition of the Ming-dynasty *Kuang Chin Shih Yun Fu* compiled by Lin Shang-k'uei and Li Ken. The book is a dictionary of the bell inscriptions and other ancient precursors of the *tensho* style.

A number of Chinese reference works on *tensho* were republished in Japan, among them *Shou Wen Chieh Tzu Chuan Yun P'u* (5 volumes; 1663) compiled by Hsu Chieh of Southern T'ang (937–75). A basic knowledge of *tensho* was gradually spreading, and knowledge of this style reached a level where a whole work of literature could be published in it. People like the priest Itsuzan (Fig. 44) and Niioki Mosho, were well known as seal engravers and at the same time were good at written *tensho*. In 1765, *Kyukokan Shosoku*, a book compiled by Den Ko, was published in Kyoto. It was a collection of *karayo* calligraphy written in Japan but included Li Ssu's *Hui Chi K'e Shih* (a stone inscription for Emperor Shih Huang-ti of Ch'in, dating from 210 B.C.). The calligrapher Ko Fuyo was best known as a seal engraver (Fig. 36) with a wide knowledge of *tensho* writing. He published in 1796 the *Kanten Senjimon*. A sixfold screen (Fig. 37) originally in the possession of his close friend Kimura Kenkado, and

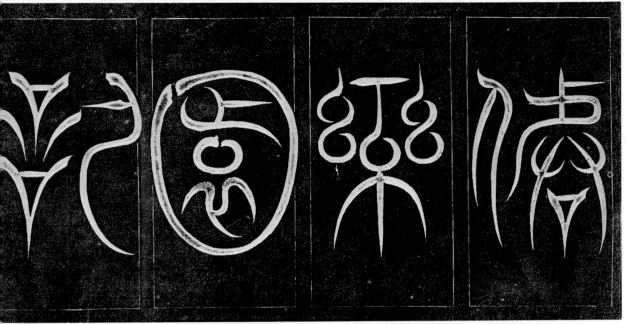

45. Tensho *by Tokugawa Nariaki (memorial stele in Kairakuen park, Mito, Ibaragi Prefecture) ; 1836. From reproduction of ink rubbing; height, 32 cm. Naikaku Bunko Library, Tokyo.*

bearing various *tensho* styles written by Ko Fuyo, is extant. Ko Fuyo's friend Ike no Taiga (1723–76), the great eccentric painter of the *nanga*, or Southern school, was another good *tensho* calligrapher.

Parallel with the popularity of seal engraving, written *tensho* also saw a brief period of activity with the appearance of good *tensho* calligraphers in the ranks of seal engravers, literati, and scholars. Presumably it attained its popularity with this class of people as a "brush and ink" pastime because of its attractive graphic qualities. In this way seal *tensho* finally came into its own as a fully Japanese style.

Even at the end of this period there were some notable *tensho* writers. The famous statesman Tokugawa Nariaki (1800–1860), daimyo of Mito, whose son Yoshinobu became the last shogun before the Imperial restoration in 1868, practiced calligraphy and was skilled in *tensho* and *reisho*. In Kairakuen Park in Mito City his inscriptions appear on plaques here and there among the elegant struc-

tures rebuilt after World War II. The Kairakuen memorial inscription (Fig. 45) in a corner of the garden is a splendid work: the title in *kobun-ten* and text in "dripping dew" *suiro-ten*. There are other *tensho* plaques by Nariaki such as "Kobuntei" (Pavilion for Enjoying Literature) or "Kosa wa sessei ni shikazu" (What is skilled but insincere is no match for something rude but sincere). For neat beauty his is the outstanding work of the period.

Ichikawa Beian (1779–1855) was also a famous calligrapher at the end of the Edo period and was the author of a prolific output of books on calligraphy and ink painting. He was attracted by the calligraphy of Mi Fu of Sung, but his *kaisho* is said to have been influenced by the T'ang calligrapher Yen Chen-ch'ing. At the age of twenty-six he went to Nagasaki and studied there under the Ch'ing calligrapher Hu T'iao-hsin. He wrote very correct, reliable calligraphy in all five styles and was considered exemplary throughout Japan. The "Yufu

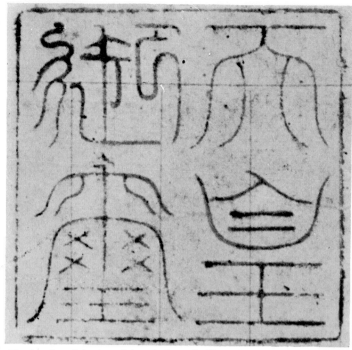

46. Imprint of the Imperial seal, from the Horyu-ji catalogue of donations (756). The characters read "tenno gyoji," or "the emperor's seal." Actual size.

Tz'u" in the possession of the Ichikawa family is representative of his *tensho*.

Another calligrapher with an excellent knowledge of the various styles was Yamanashi Tosen The "Lan T'ing Hsu" by him (Fig. 40) is a fine example of his work in *tensho*.

In the Meiji period (1868–1912), stimulated by the arrival of the Ch'ing-dynasty scholar Yang Shou-ching, Hokuhi, or Northern Inscription school, calligraphy spread in Japan. Following this, the Japanese literati and seal engravers who crossed over to Ch'ing China were influenced by calligraphers of the Ch'ing-period Hokuhi school, and started writing in this new style. Gochiku Nakabayashi (Fig. 34) and Shinsen Kitakata were among the calligraphers who followed this trend. A stream of good books was published: Mokuho Maeda's *Imbungaku,* Chushu Takada's *Choyokaku Jikan* (1901), *Kanji Shokai* (1912), *Kochu Hen* (1925), and Koseki Hattori's *Tenkoku Jirin* (1927), are typical. Thus a body of Chinese and Japanese materials on *tensho* became available.

Since *tensho* is an unusual, archaic script with richly graphic features, it has been popular with calligraphers even in recent times and is often used in calligraphic works. In addition to being the main style for seal inscriptions it is still in use among brush calligraphers in Japan today.

Reisho: Scribe's Script

THE TERM REISHO has had several meanings throughout history and nowadays it is simply used as the name of one of the five basic scripts. The *reisho* variant of the Han dynasty, *kanrei*, is representative of the style as a whole. Like *tensho* it is not one of the common scripts and is written only in special contexts. *Reisho* exhibits an extreme exaggeration of the start and finish of each stroke, and has a rude, yet stern and imposing appearance. We are reminded of the ceremonial solemnity of Han-dynasty officials governed by Confucian precepts. This style has no lyrical softness, only a display of intense seriousness and commanding dignity. For this reason it is a suitable plaque style, where the characters must be on a large scale to give the impression of strength. Appropriately enough, *reisho* is used mainly for plaques, signboards, titles of calligraphic works or paintings, book-cover titles or title pages, prefaces, etc. All these applications derive naturally from the essential nature of this style.

In Japan, hardly any *reisho* is seen before the Muromachi period, only a few examples being found on plaques, so that for works that can be appreciated as calligraphy we must wait until the Edo period.

EDO-PERIOD REISHO Ishikawa Jozan (1583–1672), who was particularly fond of *reisho*, lived at the Ichijo-ji temple on the northeast outskirts of Kyoto, in a retreat he called the Shisen-do, leading the elegant life of a man of letters of the early Edo period. He always wrote his poems in a style of *reisho* so distinctive that it is instantly recognizable (Fig. 47). The *reisho* he practiced, however, was not that of the distinguished style to be seen on good Han monuments. It seems, in fact, that Jozan's *reisho* must have been based on the unorthodox, mediocre models that circulated in the Ming period (1368–1644). As in his life style at the Shisen-do he gave himself the airs of a Ming literary man, so there is in his calligraphy something unpalatable. The bad taste of his calligraphy is dispelled, however, by the richness of his talent and the beauty of his way of life, and it is not a real cause for complaint. When one gazes at the peaceful garden of the Shisen-do on its little hill covered in greenery and looks at the framed *reisho* hung here and there in the rooms while listening to the sound of the valley stream and the periodic clack of a bamboo bird-scarer, any displeasure about his calligraphic taste seems to melt away.

Ishikawa Jozan was not the only Japanese calligrapher writing in the *reisho* style. The contemporary Confucian scholar Hitomi Chikudo wrote *reisho* in a style resembling Jozan's, and the cloistered Prince Ryosho at the Manju-in monastery wrote well in *reisho* (Fig. 48) in a style identical to Jozan's. The plaque at the Senso-ji at Edo's Asakusa shows an example of Prince Ryosho's *reisho*. Another calligrapher, Shokado Shojo (1584–1639)

47. Reisho *by Ishikawa Jozan. Seventeenth century. Paper. Shisen-do, Kyoto.*

of Yawata on the southern outskirts of Kyoto, at first studied Kukai's calligraphy and was good at *kana.* He also wrote some *reisho* (Fig. 50) resembling Jozan's. Kobori Enshu (1579–1647), the famous Edo-period landscape gardener and tea-ceremony master, also had an interest in this style of *reisho.* His style was passed on to the daimyo of Matsue, Matsudaira Fumai (1751–1818; Fig. 49), who was also a famous tea master. *Reisho* by tea masters is often seen on plaques or boxes for tea utensils.

Honcho Jifu Hiden (1907), by Tonan Maeda, illustrates sixteen types of Japanese *reisho* used by Edo-period calligraphers: *hogai* (jewelled canopy), *shusui* (gathered water), *saikaku* (rhinoceros horn), *kinto* (gold sword), *tetsujo* (iron castle), *tetsurei* (iron bell), *banryu* (coiling dragons), *yokaku* (ram's horn), *shiko* (lion's mouth), *fuga* (swimming goose), *hoshi*

(phoenix's wings), *wanjun* (curved bamboo), *kanju* (strung pearls), *gyokuan* (jeweled table), *tetchu* (iron pillar), and *shingetsu* (new moon). It is clear that these are the Ming, unorthodox kind of *reisho* I mentioned earlier, and that the *reisho* of the early Edo period must have been modeled on these basic variants. These variant styles applied to tea-ceremony wares evoke feelings rather different from those of the older Chinese *reisho,* which is based on the Chinese calligraphers' appreciation of the Han-dynasty *kanrei.* In the same way, implements brought over from China, where they were not associated with the tea ceremony, and used as utensils in the Japanese tea ceremony produce an atmosphere entirely suited to Japanese tastes. The adaptations made by the masters show us that calligraphy is not good simply as calligraphy

48. Reisho *by Prince Ryosho. Seventeenth century. Paper; each character on sheet 16.5 × 16.5 cm. Manju-in, Kyoto.*

—if it is put to proper use it becomes a living thing.

Konoe Yoraku-in Iehiro (1667–1736) was a calligrapher well versed in the various styles of Japanese and Chinese calligraphy who wrote a correct, genuine *reisho.* It had the refined kind of beauty to be seen in the Han-dynasty *Ts'ao Ch'uan Pei* inscription (Fig. 7) or the *Shih T'ai Hsiao Ching* of Hsuan Tsung of T'ang. An example of his *reisho* can be seen on the back of the monument known as the *Obaku Zenso Kosen Osho no Hi* (Fig. 63) at the Bukkoku-ji in Kyoto.

INK RUBBINGS WERE one of the principal forms of reproduction of monument inscriptions. One method of making such rubbings is to wet a sheet of paper and press it against the carved inscription in such a way that the softened paper takes on the shape of the carved surface. After allowing the paper to dry, still against the stone surface, ink is applied to those parts of the paper not pressed into the hollows of the carved out strokes of the characters. Thus on the resulting rubbing the characters stand out in white against a black ground.

In the Edo period the study of *kanrei* was extremely difficult because of the scarcity of good collections of ink rubbings. It was about the middle of the eighteenth century that Hosoi Kotaku's pupil Seki Shikyo republished the *Han Li Tzu Yuan,* a six-volume work by Lou Chi of Sung; with this the wide field of *kanrei* finally gained recognition. In 1792, Kamata Kansai of the Osaka area published a revised edition of the two-volume *Li Pien* by Ku Ai-chi of Ch'ing-dynasty China. Okuda Mototsugu

49. Reisho by Matsudaira Fumai. Late eighteenth to early nineteenth century. Paper; 33.1 × 58.8 cm.

50. Reisho by Shokado Shojo. Early seventeenth century. Paper; 101.8 × 24.2 cm.

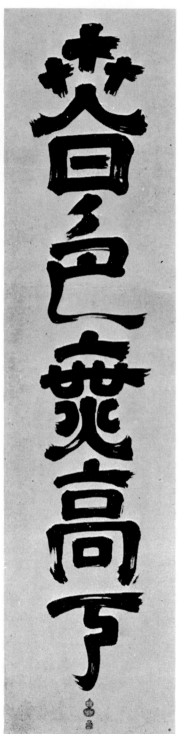

and Sawada Toko wrote prefaces praising the book because they felt that *kanrei* had been clarified for the first time by its publication. In the same prefaces they announce the forthcoming publication of four other books on *reisho*. We can judge from this that progress had been made in the study of *reisho* and that there were plans to eventually republish all the well-known works on *reisho*.

Sawada Toko was principally an admirer of Chin- and T'ang-dynasty calligraphy who also had some insight into *tensho* and *reisho*. In his *Reisetsu* (Comments on Reisho; Fig. 52), he explains that the terms *reisho* and *happun* refer to the same script, and in his preface to *Reiben* he goes into this theory in greater detail, explains the

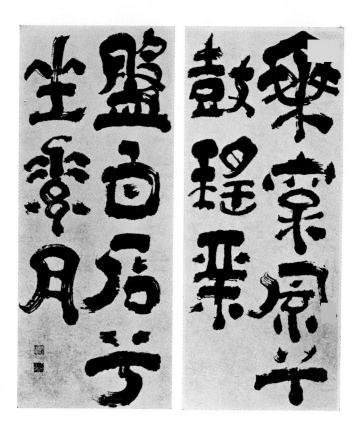

51. Reisho *by Ike no Taiga. Paper. Jisho-ji, Oita Prefecture.*

meanings of the terms, and argues that the word *happun* came into use around the Chin period (265–420).

Of the *reisho* monument inscriptions that Toko was able to see, he cited Ts'ai Yung's *Hsia Ch'eng Pei* as an exemplar of old *reisho* and, remarking that the works of the four T'ang calligraphers Han Tse-mu, Li Ch'ao, Ts'ai Yu-lin, and Shih Wei-tse were impossible for him to obtain, he gave Emperor Hsuan Tsung's *Shih T'ai Hsiao Ching* as a model of T'ang monument inscriptions. The original *Hsia Ch'eng Pei* monument was destroyed in the Ming period, and the calligraphy of the replacement is by Ts'ai Yung. There is a rubbing extant that is said to be of the Sung period, but it does not

exhibit many *kanrei* characteristics and it is doubtful whether it is a rubbing from the original monument. The copy brought to Japan in the Edo period is marked as being Ts'ai Yung's calligraphy and thus is probably a rubbing of the replacement that was engraved in the Ming period. The fact that *kanrei* was then represented by this kind of calligraphy indicates clearly the low state of *reisho*, although scholarly works like *Kanrei Jigen* and *Reiben* had been published.

The example of *reisho* given in *Kyukokan Shosoku* (1765) is also the *Hsia Ch'eng Pei*. Kan Tenju (1727–95) of Ise, who put his efforts into printing reproductions of copybooks of monument inscriptions, also used the *Hsia Ch'eng Pei* and *Ts'ao*

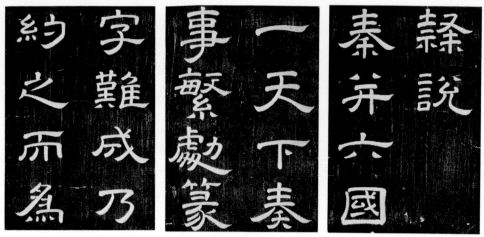

52. Reisho *from* Reisetsu, *by Sawada Toko. Published 1780.*

Ch'uan Pei as models of *reisho*. The famous painter and calligrapher Ike no Taiga sometimes wrote *reisho* (Fig. 51), and his model seems also to have been the *Hsia Ch'eng Pei*. The inscription on the monument is in rough fleshy *kanrei*, but Taiga's brush transforms it into something free and easy. Although the material is so unpromising, the result in fact serves to impress on us Taiga's determination. Bronze has been turned into gold.

The quality of Edo-period *reisho* continued to be poor until the end of the period. Even Ichikawa Beian, who made efforts to collect reproductions of monument inscriptions (Fig. 61), considered the *Ts'ao Ch'uan Pei* a peerless treasure. He said that Wang Shu of the Ch'ing period praised the *Li Ch'i Pei, Hsi Yueh Hua Shan Miao Pei, Lou Shou Pei,* and other inscriptions, but he himself had not yet been able to see them. He writes that in order to master the style of the *Ts'ao Ch'uan Pei* one should first make a careful study of the ample beauty of the T'ang emperor Hsuan Tsung's *Shih T'ai Hsiao Ching,* Liu Sheng's *Hua Yueh Ching Hsiang Pei* (a monument erected by Hsuan Tsung), etc. If one then copies the lean, tense characters of the *Ts'ao*

Ch'uan Pei with deliberate strokes, as if drawing something fat and heavy, one will achieve the feeling of "a lean, craggy strength in great suffering." He considered his own Han-dynasty inscriptions very rare, listing the following: *Wu Feng Erh Nien K'e Shih,* carved by Lu Hsiao-wang (Fig. 6); the *P'i Hsien Pei* monument; the *Tun Huang T'ai Shou Pei* monument; and the *Wang Chih Tzu Erh Ch'ueh.* We can imagine from this how difficult it must have been to get hold of good rubbings of outstanding inscriptions of the Han dynasty. In spite of these conditions he applied himself to the collection and classification of materials concerning not only *reisho* but also all the other script styles, publishing such works as the *Gotai Bokujo Hikkei.* Ichikawa Beian's friend Togawa Ren'an was also skilled in *reisho.* The inscription on the monument *Juzo no Hi* (erected by Beian in 1855) was written by Ren'an in *reisho.* There are many other examples of Ren'an's *reisho,* such as the preface to Beian's work, *Shozanrindo Shoga Bumbo Zuroku.* Tokugawa Nariaki of Mito, a *tensho* expert, also wrote outstanding *reisho.* Many examples of his *reisho* are extant: the *Kodokan no Ki* (Fig. 65)

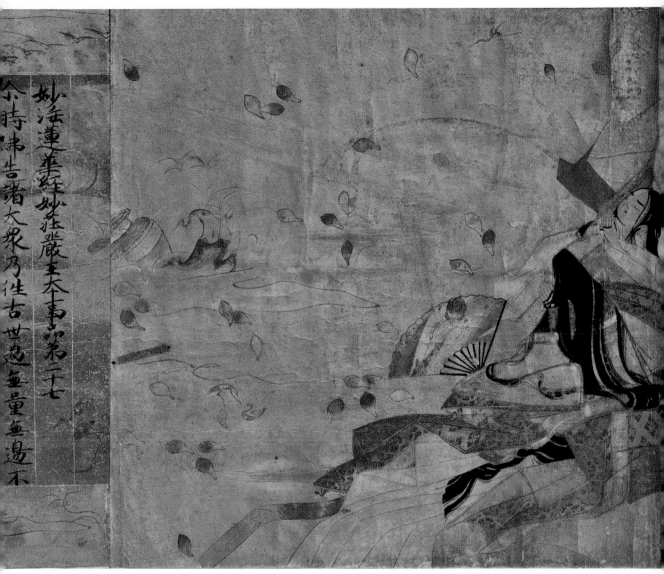

妙法蓮華経妙荘厳王本事品第二十七

余時仏告諸大衆乃往古世過無量無辺不

53. Section of Heike Nokyo. *Decorated sutra in scroll format donated to the Itsukushima Shrine by the Taira clan; 1164. Ashide design; colors on paper; height, 27.3 cm. Itsukushima Shrine, Hiroshima Prefecture.*

54. Section of Akihagi-jo, attributed to Ono no Michikaze. Tenth century. Colored-paper scroll; height, 22.6 cm. Tokyo National Museum.

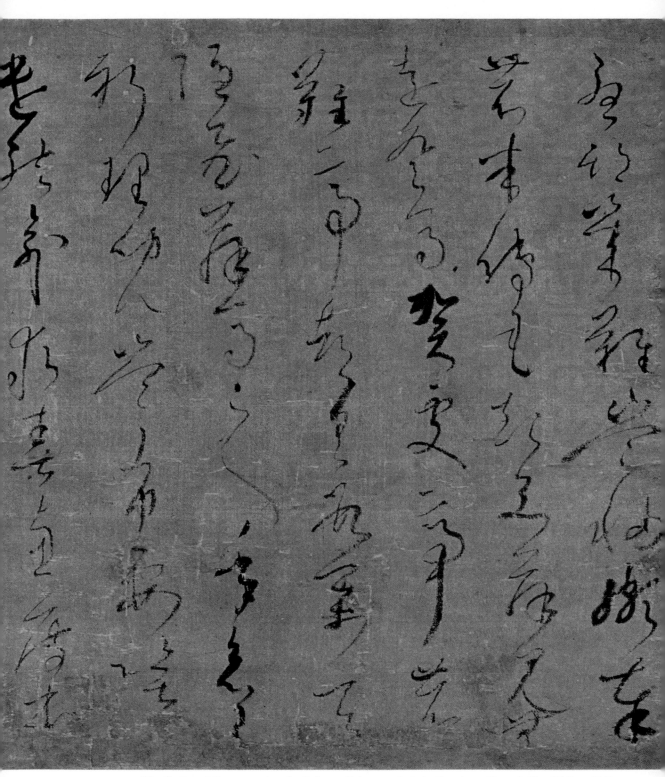

55. *Section of Ganouta-gire, by Fujiwara Sukemasa. Late tenth century. Figured silk : 28.8 × 47.7 cm.*

56. *One of a set of* shikishi *known as the* Sunshoan Shikishi, *attributed to Ki no Tsurayuki. About tenth century. Colored paper; 12.9 × 12.3 cm.; originally* detcho *glued binding. Goto Art Museum, Tokyo.*

57. One of a set of joined shikishi known as Tsugi-jikishi, attributed to Ono no Michikaze. About tenth century. Colored paper; each shikishi square, 13.4 × 13.2 cm.; originally detcho glued binding. Goto Art Museum, Tokyo.

（判読困難のため本文省略）

大宰帥大伴卿上京之後流後守葛井連大成古歌作詞一首

從今者城山道者不楽牟吾将通常念之物乎

大納言大伴卿新袍贈橘達夫喜多高安之歌一首

五衣人真裏曽網為難波堀江之手小者雜稻

大伴宿祢三依悲別歌一首

云跂良志久伯波牟小舎乃情婦之庭雨雲

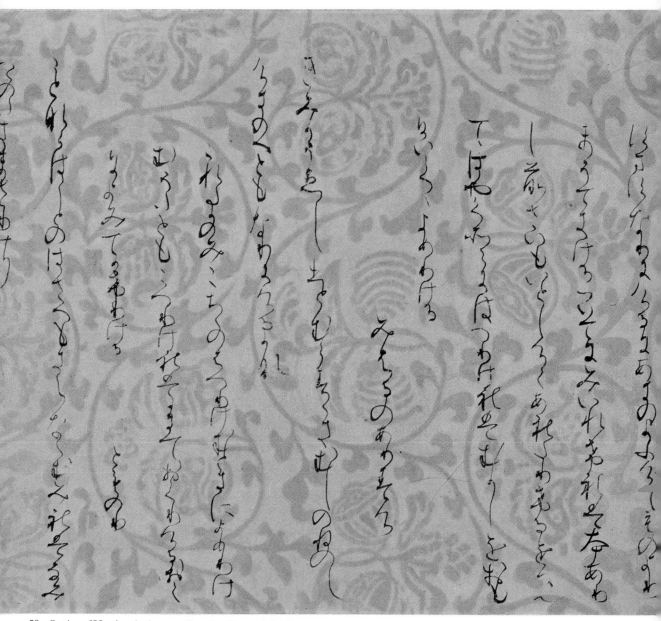

59. *Section of* Hon'ami-gire, *attributed to Ono no Michikaze. Fragment of* Kokin-shu *transcription. Eleventh century.* Karakami-*paper scroll; height, 16.6 cm. Imperial Household Collection.*

◁ 58. *Section of* Man'yo-shu *(Katsura-bon transcription), attributed to Ki no Tsurayuki. Eleventh century. Scroll of paper decorated in gold and silver; height, 26.8 cm. Imperial Household Collection.*

見天台山之高巌四十五丈波白暄長安
城之遠樹百余万荳蕎青
江戻隴涌人煙遠湖水連天鷹點之
一行科存雲掃成二月餘花聖郭孔
云眼可連孩雨家喜清新郷乿夕陽前萬戻
三行さけやなよてうちを
ぜみや末らのよ上すやれ
　　餞列
　与君没気和印文お我を朝喜一盞
前逢程壹遠馳里松尻山々霊雲侭之岁期

漁父辭

屈原既放，游於江潭，行吟澤畔，顏色憔悴，形容枯槁。漁父見而問之曰：子非三閭大夫與？何故至於斯？屈原曰：舉世皆濁我獨清，眾人皆醉我獨醒，是以見放。漁父曰：聖人不凝滯於物

61. Reisho by Ichikawa Beian ("Yufu Tz'u"); 1799. Paper.

and the *Shubaiki* pillar at the Kodokan in Mito, the *Senko Bosetsu* pillar at the Kairakuen park.

MEIJI REISHO: THE NEW WAVE

With the advent of the Meiji period in 1868, Yang Shou-ching came to Japan from China, bringing reproductions of many memorial inscriptions. Immediately Japan's calligraphic field of vision broadened, and along with increased contact between China and Japan, the style of the Hokuhi school was introduced into Japan, changing Japanese *reisho* forms drastically. First among the calligraphers of the day who made names for themselves as writers of memorial inscriptions is Meikaku Kusakabe (1838–1922). He went to Ch'ing China and studied with Yang Chien-shan (1819–96); his debt to Yang Shou-ching is equally great. The thousand or so steles bearing his inscriptions are widespread in Japan. The *Enjoken Doshi Iseki* pillar at the Gotoku-ji temple in Tokyo's Setagaya Ward, the *Yushima Tenjin Issennen Sai no Hi* pillar in the grounds of Tokyo's Yushima Tenjin shrine, the *Iwaya Ichiroku no Hi* pillar (Fig. 62) in the Daiko-ji temple in Minakuchi-machi, Shiga Prefecture, and the *Ono Kozan Bohi* pillar in the Dairyo-in, a subtemple of the Myoshin-ji in Kyoto, are

◁ *60. Section of* **Wakan Roei-shu** *(Konoe-bon transcription), attributed to Fujiwara Yukinari. About mid-eleventh century. Karakami-paper scroll; height, 25.8 cm. Yomei Bunko Library, Kyoto.*

62. *Section of* Iwaya Ichiroku no Hi. Reisho *by Meikaku Kusakabe;* *1911. Ink rubbing of memorial stele; height, 250 cm. Daiko-ji, Shiga Prefecture.*

63. Reisho *by Konoe Iehiro.* *Draft for stele inscription; 1711.* *Paper. Yomei Bunko Library, Kyoto.*

64. Kodokan no Ki *(1838), by Tokugawa Nariaki. Ink rubbing of heading in* tensho *script. (See Fig. 65 for main inscription.)*

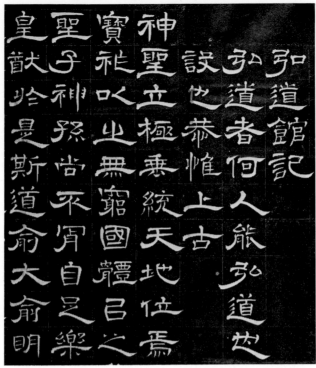

65. Section of Kodokan no Ki, *by Tokugawa Nariaki. Reisho; 1838. Ink rubbing in Naikaku Bunko Library, Tokyo. (See also Fig. 64.)*

famous examples of his *reisho.* Many of Meikaku's disciples were also skilled in *reisho.*

Nowadays most of the famous Han-dynasty stele inscriptions can be seen in the many Chinese and Japanese reproductions of monument rubbings. Works like Hung Kua's *Li Shih* (Sung dynasty), Weng Fang-kang's *Liang Han Chin Shih Chi* (Ch'ing dynasty), Wang Ch'ang's *Chin Shih Ts'ui Pien* (Ch'ing dynasty), and Yang Shou-ching's *Huan Yu Chen Shih T'u* (Ch'ing dynasty), are widely read, so that there is no lack of Han inscriptions for appreciation and study.

Essentially *reisho* is a special-use script that still functions in society. As long as *kanji* are used, *reisho* will continue to be used and further refined as both an artistic and a practical style.

CHAPTER FOUR

Zattaisho: Ornamental Styles

ZATTAISHO BY KUKAI *Zattaisho* are ornamental variants of seal *tensho* and scribe's *reisho*. They were fashionable in the Chinese Southern dynasties of the Ch'i (479–502) and Liang (502–57) periods and persisted into the T'ang period; the number of variants are said to have been 100 or 120. The *Torige Tensho Byobu* (Figs. 13, 23) in the Shoso-in Repository marks the introduction of this style to Japan. After this screen, the best example of *zattaisho* is the inscription on the monument at the Masuda Pond, *Masuda no Ike no Himei,* by Kukai.

The text of this inscription (Fig. 68) is presented in the *Shoryo-shu,* a collection of Kukai's writings. The stele was erected in 825 to commemorate the completion of the Masuda Pond in Kyoto. One passage extols the blessings of heaven and the virtues of the people, describing the uncontrolled delight of high and low alike. It goes: "Mandarin ducks and snipe sport on the waters, singing. The long-lived black crane and the snow goose vie with each other in dancing playfully at the water's edge. The turtle stretches its neck. Roach and carp flip their tails. The otter of the depths spreads out its catch of fish on the bank like votive offerings. The crow in the woods feeds its nestlings." Another passage says: "When the one man has joy, the myriad people put their faith in him. They dance and skip, slap their bellies, and, clapping their hands and stamping their feet, shout 'Long live,' and so forget their labors." The scroll is of five-colored silk and the script styles used are reminiscent of the forty-three styles in Hsiao Tzu-liang's *Chuan Li Wen T'i* (Fig. 21). The keynote of the calligraphy is *sosho,* but this is varied with scripts like "cloud writing," "dripping dew," "snake writing," "goose head," "hanging needles," "tiger's claws," "dragon's claws," etc. In particular the characters at the end of the scroll, which seem to be gyrating and jumping about, clearly correspond to the "snake writing" style. The diversity of the numberless variations of scripts employed in the scroll seems truly suited to the expression of joyous felicitations on an auspicious occasion such as this.

By imperial command in 816, Kukai wrote an inscription on a fourfold screen that is five feet high. The inscription is written on five shades of Wu damask with a brocade border and it contains references to "goose heads," "dragon's claws," "auspicious grasses," etc. Judging from this passage, the inscription on this screen seems to have been written in *zattaisho* styles to be seen in the *Chuan Li Wen T'i* such as: "bird script," "dragon's claws," "snake script," "serpent script," "cloud script," "falling leeks," "dripping dew," "hanging needles," "cranes' heads," "crescent waves," "camelopards," "phoenix," "auspicious grasses," "special luck," etc. Through the use of a variety of *zattaisho* scripts, Kukai seems to have expressed the true spirit of the relationship between ruler and subject, husband and wife, young

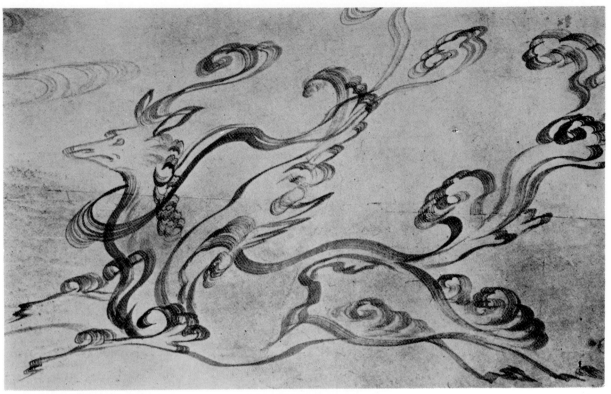

66. *Camelopard* (kirin) *in* hihaku *brushwork. Eighth century. Shoso-in, Nara.*

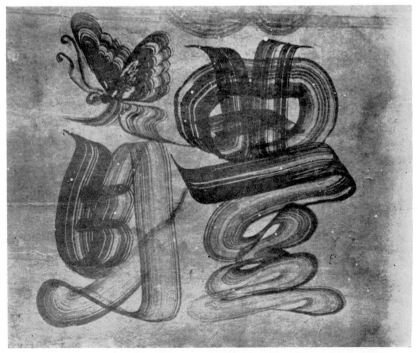

67. *Detail from* Ju Nyoze, *attributed to Kukai.* Hihaku *ornamental script. Early ninth century. Paper. (See also Fig. 69.)*

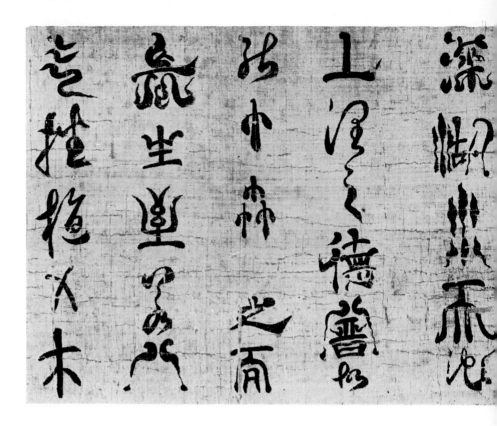

and old, brothers and sisters, etc. As mentioned earlier, the Chinese custom of using *zattaisho* for writing on brightly colored, richly decorated screens appears to have found its way to Japan. The scroll of the text of the *Masuda no Ike no Himei* preserved in Shakamon-in on Mount Koya, the Shingon sect's head temple built by Kukai, may not actually be by Kukai. Compared with the text in the *Shoryo-shu* anthology, the Shakamon-in version reveals many omissions and inversions. Moreover there are some things about the calligraphic style that make it impossible to believe that the text is actually Kukai's; it is most probably a later copy. In 1906, a stele with a carved

inscription based on this scroll was erected behind the Kume-dera temple in Nara.

Among the famous Portraits of the Seven Patriarchs of Shingon Buddhism, those of Ryumyo, Kongochi, Fuku-Kongo, and Zemmui have inscriptions attributed to Kukai in the *hihaku* script style (Fig. 31). *Hihaku* is sometimes treated as an independent calligraphic style, but it is also included among *zattaisho*. The skill with which these inscriptions are written varies to a certain extent, but the writing on each displays a subtle touch, and the beautiful *hihaku* brushstrokes swirl magnificently, suggesting the *nuno-sarashi* dance, in which dancers manipulate long, ribbonlike pieces

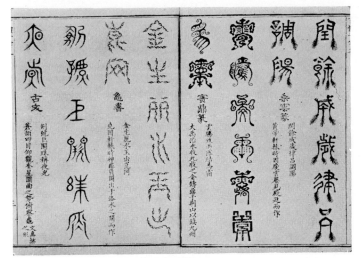

70. *Two pages from* Li Chao Sheng Hsien Chuan Shu Pai T'i Ch'ien Tzu Wen, *compiled by Sun Chih-hsiu. Published 1689 (Ch'ing dynasty).* The Thousand Character Essay *in 125* zattaisho *ornamental styles.*

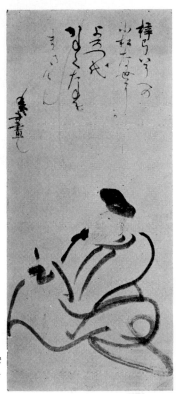

71. Moji Hitomaro, *by Konoe Nobutada. Representation of the poet Kakinomoto Hitomaro made up of characters. Late sixteenth to early seventeenth century. Paper, 85 × 36.7 cm.*

meaning "wood" or "tree" in one character is replaced by a realistic representation of a tree; in another character the "man" element is replaced by a representation of a man. Another striking device is the use of swallows and butterflies for short strokes in some characters (Figs. 67, 69). These decorative elements suggest that it is best to regard this style as a form of *zattaisho*. Among the books Kukai brought back from China and presented to the court is a work called *Niao Shou Fei Po* (Bird and Beast *Hihaku*), a title that probably refers to the kind of calligraphy we have just discussed. The style resembles in principle styles mentioned in Hsiao Tzu-liang's *Chuan Li Wen T'i*. For instance, in "turtle writing" the character *shutsu* (出) is represented by a turtle drawn to resemble the character. Or alternatively, several turtles are used instead of brush strokes, being grouped together to compose a character. This style was probably practiced as part of the *hihaku* style. It seems to be a playful style that aims at a decorative effect by simply inserting pictorial elements among *hihaku* characters.

A *hake* (broad brush) drawing in light brown on white hemp paper preserved among the pictures in the Shoso-in Repository shows swallows, phoenixes, and camelopards flying among scudding clouds, while white clouds are depicted on the back (Fig. 66). The *hihaku* brushwork used for these clouds shows a close resemblance to the brushwork of the Seven Patriarchs inscriptions and that of the *Ju Nyoze*. Like the *Ju Nyoze*,

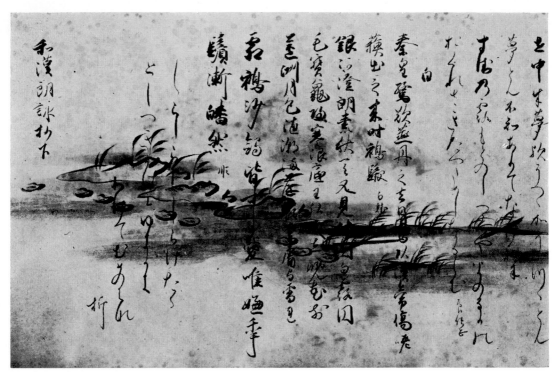

72. *Section of* Wakan Roei-shu *(Eiryaku-bon transcription), by Fujiwara Koreyuki; 1160. Scroll of paper decorated in the* ashide *style; height, 28.3 cm.*

swallows are depicted in this drawing and this cannot be a mere coincidence. Perhaps this was a common Nara-period motif that found its way into the *Ju Nyoze*.

ZATTAISHO AFTER KUKAI

After Kukai, *zattaisho* scripts appear hardly anywhere except in inscriptions on plaques. Exceptions are the *ashide* and *uta-e* scripts (Fig. 72) used in the Heian period, for these too can be regarded as kinds of *zattaisho*.

Zattaisho can be seen again in Edo-period works. The Tokugawa family's Hosa Bunko library in Nagoya has a volume titled *Tensho*. This book has been in the possession of the Imperial Household and was in the collection of Tokugawa Yoshinao, one of Tokugawa Ieyasu's sons and first head of the Owari branch of the Tokugawa family. The work gives examples of some seventy varieties of *zattaisho*. In 1692 Katori Tessai published *Shinsaku Kotei Shoka Tempo Senjimon* in Edo. This work was printed from woodblocks and gave the *Senjimon* (Thousand Character Essay) in seventy-two *zattaisho* variants of *tensho*. Seal carving of the Ming-Ch'ing Modern School was popular in Edo at that time, and a taste for the decorative variants of *tensho* and *reisho* was widespread. Probably the work was published to fill the demand for this kind of book, which could serve as a sourcebook for seal engravers. A Ch'ing work published in

1689, *Li Chao Sheng Hsien Chuan Shu Pai T'i Ch'ien Tzu Wen* (Fig. 70), compiled by Sun Chih-hsiu, also gives the "Thousand Character Essay," in 125 different styles. A Japanese edition of this book appeared during the Edo period, and it was reissued in the Meiji period. This work was principally produced for the convenience of seal engravers of the modern-style school, and it was used as a sourcebook for making the type of seals known as *fukuju-in* (good luck seals) or *hyakuju-in* (hundred long-life seals). The common custom of presenting on auspicious occasions a calligraphy consisting of the character *ju* (long life) written out in a hundred different styles is an expression of good wishes, and for this too, the *zattaisho* scripts are used. The calligraphy by Konoe Iehiro (Fig. 118) written in gold on satin is a beautiful example of this custom.

There are, in addition, many other forms of "playful characters," although these are different in feeling from *zattaisho*. An old example is a portrait of Toto Tenjin (the deified courtier Sugawara Michizane) drawn with only one wetting of the brush. Another example is a sketch of the poet Kakinomoto Hitomaro made from characters called *Moji Hitomaro* ("Characters" Hitomaro; Fig. 71). There is a calligraphy by the painter Tomioka Tessai in which the three characters *fuku-roku-ju* (luck, wealth, long-life) are skillfully fitted together into one character. Like *zattaisho*, this is a form of recreation. Still many other unofficial, playful characters are to be seen in graffiti and doodles.

The *zattaisho* scripts that are ornamental variants of *tensho* and *reisho* are used with considerable freedom of form and coloring. They are widely used as decorative designs on other media like pottery or lacquerware. Recently, ornamental characters and lettering have become a specialized field of study, but there should be wider recognition of the fact that scripts of this kind have been used in the East since ancient times.

CHAPTER FIVE

Gakuji: Plaque Inscriptions

WHEN VISITING old temples and shrines, one often sees calligraphy on plaques, usually giving the names of the structures on which they are hung. The calligraphy on these tablets is generally attributed to famous calligraphers of the past like Kukai, Ono no Michikaze, Kanko, and others. Sometimes a calligrapher writes the inscription directly on the wood in ink. Sometimes he writes it on paper and has a facsimile carved on the board by a professional carver. Occasionally, a calligrapher may do the carving himself. We know that the practice of hanging plaques, or *hengaku,* as they are called in Japanese, existed in palace pavilions in China as early as the Han dynasty. In Japan too, the custom prevailed from early times, and examples of such early plaques are extant. "Konkomyo Shitenno Gokoku no Tera" (Fig. 73) at Todai-ji in Nara, an inscription attributed to Emperor Shomu, and the inscription of the temple's name at Toshodai-ji, attributed to Empress Koken, are outstanding examples. Many more *hengaku* examples are still to be seen at old temples and shrines in Nara and Kyoto, and there are many large ones at Zen temples of the Kamakura and Muromachi periods. Surviving from the Edo period on are countless *hengaku* used by inns and tea houses.

Matsudaira Sadanobu's *Shuko Jusshu* (85 vols.) includes a section on the principal inscriptions on plaques found in Japanese palaces, shrines, and temples. In this the author tells us: "The style for title writing arose in the Ch'in and Han dynasties. Outstanding practitioners of this country received the tradition from talented calligraphers of the Sui and T'ang dynasties. Palace plaques brilliantly manifested the rulers' glory. However, from the middle period the strands of the great hawser of the ruler's authority broke and the palaces fell into disrepair. Due to this, the famous writings were lost. The few remaining vestiges are in the form of copies by calligraphers of various schools. I include them all here. To be seen from time to time are some that escaped the ravages of war by reason of being in remote temples and shrines. Reproductions of these are also included here." The plaque inscriptions presented in this work are from the Nara, Heian, Kamakura, Muromachi, and Edo periods. There are quite a few examples from the Nara and Heian periods, although many of the plaques have long since been replaced by later copies. Included are works by Emperor Shomu (Nara); the *sampitsu* (three great calligraphers) of Heian; the *sanseki* (Ono no Michikaze, Fujiwara Sukemasa, and Fujiwara Yukinari); representatives of the Seson-ji, Shoren-in, and Jimyo-in schools; Fujiki Atsunao of the Daishi school; and various emperors, members of the shogun's family, gifted calligraphers, and high-ranking Chinese and Japanese monks. There is frequently no signature on the older works, but starting in the Edo period signatures and seals were occasionally used, so the authorship of the latter works is clear.

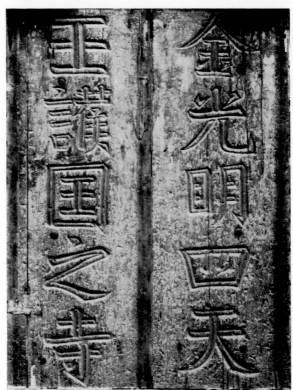

73. *"Konkomyo Shitenno Gokoku no Tera."* Plaque giving a temple name. Attributed to Emperor Shomu. Eighth century. Wood, 154 × 113 cm. Todai-ji, Nara.

Among all the calligraphers represented in this collection, works attributed to Kukai are probably the most numerous, and among these are large amounts of his strange, unique *zattaisho*. Some of the calligraphic specimens that appear here closely resemble the styles of covers from Chinese tomb epitaphs and *tengaku* (stone-inscription titles in *tensho* script) from the Six Dynasties to the T'ang period. This is probably because they were influenced by Chinese models.

Originally, writing on plaques was mainly in *tensho, reisho,* and *zattaisho;* however, later on *kaisho* was often used for this purpose. In China large characters were often called by the special term *pai k'e.* This actually refers to the spacing of characters used for seal carving, so it is not a correct appellation. However that may be, there is no doubt that there was a special writing method for *hengaku.* From early times there are stories of the trials and tribulations involved in writing plaques for high palace buildings. For instance, in the Wei dynasty when the Ling Yun T'ai—a recreation pavilion "as high as the clouds"—was being built, Emperor Ming had the famous calligrapher Wei Tan write the plaque inscription. Wei had a platform built at a height of seventy-five meters and climbing to it, wrote the inscription. When he got down his hair had turned white from unbearable

74. *"Shishii-den." Plaque by Okamoto Yasutaka. Early nineteenth century. Wood; overall size, 137 × 104 cm. Kyoto Imperial Palace.*

fright. He admonished his children not to become calligraphers.

The *Yakaku Teikinsho*, by Fujiwara Koreyuki, lists the inscriptions on the gates of the Imperial Palace in Kyoto, all of which are by famous calligraphers of the past, including Kukai, Ono no Yoshiki, Emperor Saga, Michikaze, and many others. We know from this work that all the buildings and gates of the palace originally had plaques. The present palace buildings date from the reconstruction in 1855, and only the plaques of the Shishii-den (Fig. 74) and the Jomei-mon gate (Fig. 75) are still there.

The *Shukozu*, a work issued by the scholar and seal engraver To Teikan in 1768, includes copies of the plaque inscriptions of palace buildings and gates. Figures 76 and 77 show five building inscriptions: Shunko-den, Ninju-den, Shishii-den, Jonei-den, Ummei-den. Figure 78 shows four of the gate inscriptions: Choraku-mon, Sen'yo-mon, Gishu-mon, Kenrei-mon. There is a note for the Sen'yo gate saying: "Tenth month, 1255. Copied from a book in the collection of Rengeo-in." For the Choraku-mon gate there is a similar note, showing that these inscriptions go back to the mid-thirteenth century. It appears that many of these copies and tracings were passed down in the families of *sho-hakase*, or doctors of calligraphy at the Government University, and the families of courtiers serving as official scribes. The names of the Jimyo-in and the Kazano-in families appear in these books of reproductions, as does also that

75. "Jomei-mon." Plaque by Okamoto Yasumasa. About 1855. Wood; overall size, 183 × 116 cm. Kyoto Imperial Palace.

of Okamoto Yasutaka (1818–51), a *sho-hakase*.

Matsudaira Sadanobu, the compiler of *Shuko Jusshu* (see page 76), was in charge of the reconstruction of the Kyoto palace at the end of the eighteenth century, and must have investigated the history of palace plaques. His *Shuko Jusshu* includes plaque inscriptions from these buildings and gates, and he attributes the plaques of the Sen'yo-mon and Choraku-mon gates, and the Shogyo-den and Jokan-den halls, to Kukai.

The Myogi-mon gate inscription is attributed to the Minister of the Left Horikawa Toshifusa. Matsudaira says it is not clear who wrote the other inscriptions.

The Kyosho-den plaque is in *sosho* script, the Myogi-mon and Ueki-mon in *gyosho*, and the Jonei-

den and the Kenrei-mon in *zattaisho*. The character *ken* of the Kenrei-mon plaque is identical with one appearing at the end of Kukai's *Masuda no Ike* inscription (Fig. 68 shows a part of this), and for this reason this plaque inscription is thought to derive from Kukai. The Sen'yo-mon inscription is in a similar style. The Shishii-den, Ninju-den, Shunko-den, Gishu-mon, and other inscriptions use a kind of *reisho,* but one which is stylized and different from the normal form. The characters have the imposing gravity proper to plaque inscriptions. The form of the characters of the Shishii-den plaque is particularly fine. The present plaque inscription of the Shishii-den hall is by Okamoto Yasutaka of the Daishi school, and it is not the same as the reproduction in the *Shuko Jusshu*. Nevertheless it is also

76. *Reproductions of plaque inscriptions from* Shukozu, *compiled by To Teikan; 1768. (Left) "Shunko-den"; (center) "Ninju-den"; (right) "Shishiiden." Kyoto City University of Arts.*

77. *Reproductions of plaque inscriptions from* Shukozu, *compiled by To Teikan; 1768. (Left) "Jonei-den"; (right) "Ummei-den." Kyoto City University of Arts.*

78. Reproductions of plaque inscriptions from Shukozu, *compiled by To Teikan; 1768. (From left to right)* "Choraku-mon"; "Sen'yo-mon"; "Gishu-mon"; "Kenrei-mon." *Kyoto City University of Arts.*

written in a beautiful style. The works passed down in these books of copies are traced reproductions, so although some distortion is unavoidable, they are essentially accurate copies.

The methods of plaque writing in Japan have been passed down in detail in the manuals of the various shools. Examples of such manuals are *Kirinsho* and *Kingyoku Sekidenshu Shogaku Shidai*. Some of the methods have magical implications. Volume three of *Kirinsho*, for instance, instructs that plaques for temple pagodas should be written with characters resembling devils, as this will keep devils away. Other methods are more of a symbolic nature. All characters should be written in soft and supple strokes so as to symbolize the compassionate mercy of the Buddhas and Bodhisattvas. We can see that methods for writing every kind of stroke were passed down and that each kind of stroke had

a symbolic significance. Thus the ancient, sometimes bizarre techniques transmitted for writing plaque inscriptions involved religious conventions, and were not purely ornamental.

The plaques at the Kencho-ji and Enkaku-ji temples in Kamakura written by, among others, the Chinese Zen monk Wu-chun Shih-fan of the Southern Sung period, and the plaque by Chang Chi-chih (1186–1266) at Tofuku-ji in Kyoto (Fig. 79) are fine examples of plaques at Kamakura-period Zen temples. Beautiful ones by the Ashikaga shoguns Yoshimitsu and Yoshimasa at Kinkaku-ji, Ginkaku-ji, Rokuo-in, and Rinsen-ji at Kyoto represent the Muromachi period. At the Mampuku-ji in Uji there are an immense number of plaques and one can appreciate to one's heart's content the works of the Chinese monks of the Obaku sect who came to Japan: Hiin, Ingen, Mokuan, Sokuhi,

79. "Hojo" (Abbot's Quarters). Plaque attributed to Chang Chi-chih. About thirteenth century. Paper, 44.3 × 103 cm. Tofuku-ji, Kyoto.

Kosen, Essan, and others (in Chinese: Fei Yin, Yin Yuan, Mu An, Chi Fei, Kao Ch'uan, Yueh Shan). The two huge characters of the building's name on a plaque hanging in Mampuku-ji's Hatto (Dharma Hall) are known throughout Japan. They were done by Ingen in *kaisho*. Most of these plaques are written in a special Obaku style of *gyosho*, but Kosen has plaques in *tensho* and *reisho*.

Plaque inscriptions are mainly in variants of *tensho* and *reisho*, or *kaisho*; moreover they can be divided into Chinese (*karayo*) and Japanese (*wayo*) styles. The phrases used have a profound flavor, and one can find all kinds of variation of form and style in these inscriptions. Even within Japanese calligraphy, plaque inscriptions are a genre with a flavor all its own.

CHAPTER SIX

—•—

Kaisho: Block Script

KAISHO—IN MANY WAYS comparable in function and feeling to block capitals in Roman script—is the basic form of *kanji* and its most important use is as an easily legible workaday style. Japanese *kaisho* is based on Chinese *kaisho,* and we will examine it from the basic Chinese concepts.

SUI AND T'ANG INFLUENCE The Sui- and T'ang-dynasty culture was introduced into Japan in the Asuka period. The extant examples of Japanese calligraphy from that period are mostly inscriptions on stone or metal. Among these are: the inscription on the statue of Yakushi at Horyu-ji (c. 607); the inscription on the statue of Shaka Buddha (623; Horyu-ji; Fig. 81); and the pillar inscription of the Uji bridge (646; Fig. 83) at the Hashi-dera temple in Uji. The style of these has much in common with that of Sui and early T'ang times. Representative of the many copied sutras brought from Sui China is the *Kengokyo* dated 610. The script style bears a close resemblance to that of the above-mentioned stone and metal inscriptions. As well there is the bronze-plaque inscription of a commentary on the Lotus Sutra (686) at Hase-dera (*Hokke Sesso Doban no Mei;* Fig. 159) and the *Kongojo Darani Kyo* (686; Fig. 88). These are in a style identical with the two inscriptions by Ou-yang T'ung of T'ang (his father was Ou-yang Hsun): *Tao Yin Fa Shih Pei* (a monument to the priest Tao Yin; 663) and *Ch'uan Nan Sheng Mu Chih* (679). They are written with the so-called Ou technique, a characteristic and remarkable style. The above Japanese inscriptions must be understood as works based on Chinese influence. Their background is the world of sutra copying. And Japanese *kaisho* reached its high level under the influence of Sui and T'ang sutra copying.

Many of the stone and metal inscriptions of the Nara period are extant. Among these the calligraphy of the *Oharida no Yasumaro Boshi* (729; Fig. 82) is particularly good. This piece is also thought to be influenced by the study of the old style of Sui and early T'ang calligraphy. The bell inscription at the monastery of Kobuku-ji (727) is unfortunately worn down but seems to be in the same fine style. The calligraphy of the catalogue of donations to Todai-ji (Figs. 15, 85) is the finest example of calligraphy in this tradition.

In the early Heian period we can see the influence of T'ang calligraphy. Representative *kaisho* of the time are the brass lantern inscription at the Kobuku-ji (*Nan'endo Dotodai Mei;* 816; Fig. 94) attributed to Tachibana Hayanari, the bell inscription at Jingo-ji by Fujiwara Toshiyuki (Fig. 95), and the Docho-ji bell inscription attributed to Ono no Michikaze (Fig. 96). The technique of the brass-lantern inscription best achieves the ideal of traditional Chinese techniques, closely resembling the *Hsiao Tan Pei* by Pei I-yuan of Liang. Whenever there are two appearances of the same character in close proximity, some variation is intro-

80. Section of Kengokyo, *dated 610. Paper, 25.9 × 50 cm. Shoso-in, Nara.*

duced—at times even *gyosho* brushwork being used. This kind of detail is in accordance with the old techniques and shows that the writer of this inscription was no mediocre calligrapher. The bell inscription at Jingo-ji reminds us of the T'ang writer Hsu Hao and the Docho-ji bell inscription is in the style of fine sutra copies. From these we can see that early Heian *kaisho* took in the best of the traditional Chinese technique.

From the time of Emperor Daigo in the early 900s, along with the development of *kana* there was a movement toward the *wayo* style. The *Poems by Po Chu-i in Three Scripts* (Fig. 98) written by Ono no Michikaze is a good example in *kaisho* of this tendency. Besides this, volume three of the *Hokuzansho* (calligraphy by Fujiwara Kinto—a discourse on official etiquette; Fig. 100) and the *kaisho* parts of

the *Detcho-bon Wakan Roei-shu* (Fig. 124) are in the same tradition. (The *Wakan Roei-shu* is an anthology of *waka* and Chinese poems compiled by Fujiwara Kinto. The calligraphy of this particular version in the *detcho-bon* format is attributed to Fujiwara Yukinari.) These accord with the traditional *kaisho* technique—the brushwork sharp and powerful, cohesive in structure, and somehow acquiring a Japanese flavor. Along with *kana* we can think of this style of *kaisho* as most suitable to Japan.

SUNG, YUAN, AND MING INFLUENCE

The calligraphy of Sung and Yuan China inundated Japan for a second time in the Kamakura and Muromachi periods (1185–1568). It was mainly carried over by Zen monks,

法興元卅一年歳次辛巳十二月鬼
前太后崩明年正月廿二日上宮法皇
枕病弗悆于食王后仍以勞疾並著於床時王后王子等及與諸臣
懷愁毒共相發願仰依三寶當造
釋像尺寸王身蒙此願以轉病延壽安
住世間若是定業以背世者往登浄土
早昇妙果二月廿一日癸酉王后即世翌日
法皇登遐癸未年三月中如願敬造
釋迦尊像并侠侍及荘嚴
竟乗斯微福信道知識現在安隱
出生入死隨奉三主紹隆三寶遂共彼
彼岸普遍六道法界含識得脱苦緣
同趣菩提使司馬鞍首止利佛師造

81. Engraved inscription on gilt-bronze nimbus of statue of Shaka Buddha. Dated 623. Size of inscription, 33.9 × 33.9 cm. Ink rubbing. Horyu-ji, Nara.

82. Oharida no Yasumaro Boshi. *Tomb inscription; 729. Engraved on gilt bronze. Height, 29.6 cm. Tokyo National Museum.*

83. Ujibashi Dampi. *Inscription on memorial stele at Hashi-dera temple in Uji. Dated 646. Size of inscription, 36.3 × 14.8 cm. Ink rubbing. Hashi-dera, Kyoto.*

so extant works from that period are largely theirs. Proper *kaisho* from this time is scarce because the technique of Zen monks is based on Zen inspiration and thus differs from the ordinary style. Dogen (1200–1253), the great Buddhist priest who founded the Eihei-ji temple and established the Soto sect of Zen in Japan, like the scholar-monk Kokan Shiren of Tofuku-ji, had studied the calligraphy of Huang Shan-ku, but the *kaisho* calligraphy of these priests also is basically not the orthodox style.

During the time of the Northern and Southern Courts period (1336–92), works that took on the Yuan styles of Chao Tzu-ang and others were produced by Zen monks who had studied in China. But, as before, there is not much good *kaisho* among these works. In the Muromachi period, Zen monks appeared who had traveled to Ming China and studied early-Ming *kaisho*. Zekkai Chushin (1336–

84. Buddhist verse. Calligraphy by Zekkai Chushin. About late fourteenth century. Paper, 33.4 × 33.4 cm. Shokoku-ji, Kyoto.

1405) studied calligraphy under Ch'ing-yuan Huai-wei; he wrote a T'ang style of *kaisho* (Fig. 84). While in China, Chuho Chusei, who was accomplished in *kaisho*, was asked by the Ming emperor Ch'eng Tsu to write the characters to be used on the coins of that era. At that time Yu Shih-nan's style of writing was practiced in the Ming court and Shen Tu and Shen Ts'an emerged as masters. We also know that Japanese monks who crossed over to China studied Yu Shih-nan's style. Perhaps for these reasons, in the Zen temples and monasteries of Muromachi times, we can sometimes see his kind of T'ang *kaisho*.

EDO AND MODERN PERIODS Accompanying the rise of Chinese-style calligraphy in Edo, copybooks were obtained from China and *kaisho* was studied

diligently. However, since clear copies of monuments were scarce, and Japanese printed editions shoddily done, there could be no expectation of real development. One such widely used book was *Nei Ke Mi Ch'uan Tzu Fu*, compiled by a Ming Chinese—an introduction to brushwork at a very popular level that is of little use for high-level appreciation. However, Sawada Toko, who was known as a leading *karayo* exponent, was a calligrapher well-practiced in *kaisho* (Fig. 97). He recommended the following as models for this style. For small *kaisho*: Chung Yu's *Chien Chi Chih Piao* and *Jung Lu Piao*; Wang Hsi-chih's *Lin Li Ming Piao, Hsuan Shih Piao, Yueh I Lun, Huang T'ing Ching, Ts'ao Wo Pei*, and *Tung Fang Shuo Hua Tsan*; Wang Hsien-chih's *Lo Shen Fu*; and Yu Shih-nan's *P'o Hsieh Lun*. For medium *kaisho*: Yu Shih-nan's *K'ung Tzu Miao T'ang Pei*, and Ou Yang-hsun's

奉 太 網 鈎 生 故 上 僧 而 先 歡 祥 上 增 積 先
為 上 是 而 又 有 伏 正 遇 帝 相 地 凌 穀 酷 帝
入 天 壯 利 啻 歸 惟 波 惡 陛 保 不 滄 抹 意 陛
東 皇 所 物 滅 依 十 流 統 下 諸 惜 海 擇 稱 下
大 捨 以 開 之 則 伏 沙 四 德 期 弥 而 落 深 捨
寺 國 自 智 域 成 惟 而 拂 合 幽 人 懇 陳 破 國
顗 家 在 鏡 蠹 罪 而 南 而 乾 途 民 來 駈 后 家
文 珎 大 而 元 到 楊 坤 有 福 加 難 主 珎
皇 寶 雄 濟 量 化 林 明 阻 恒 於 七 而 寶
太 等 天 世 供 及 聲 並 閲 謂 天 無 種
后 人 逵 養 振 籠 日 永 千 雁 微
御 皇 師 常 則 旦 天 月 悲 秋 福 漸 聖
製 太 佛 樂 獲 鑒 竺 崇 凉 萬 神 皇 靈
后 垂 之 福 真 菩 三 靈 歲 祗 天 故
御 法 群 元 和 提 寶 壽 合 里 而 今
製 使 無 不 奉
珎 擾 為
寶 之
種 廷
説
好
及
御
帶

Chiu Ch'eng Kung Li Ch'uan Ming and *Yu Kung Kung Pei.* For large *kaisho:* T'ao Hung-ching's *I He Ming,* Yen Chen-ch'ing's *Yen Shih Chia Miao Pei,* and Liu Kung-ch'uan's *Hsuan Mi T'a Pei.* These are selections suitable for a copybook, carefully considered as to range and types of calligraphy.

The three prominent calligraphers at the end of the Edo period were Ichikawa Beian, Nukina Kaioku, and Maki Ryoko (Fig. 99). Beian had studied all the scripts and was particularly well versed in *kaisho* and *gyosho.* In his great work *Kaigyo Waihen* in fifteen volumes he pursues the script

styles to their sources. Kaioku concentrated on the old Chinese works that had been passed down to Japan, and excelled among other calligraphers because of his elegant manner and interest in the old techniques. He is most famous for having copied the calligraphy of *Cheng Shen Tse,* a T'ang manuscript at Enryaku-ji. Ryoko set forth a detailed study of characters in his *Juttai Genryu.* His calligraphy derived from the T'ang *kaisho* style and was uniquely his own.

In the Meiji period, the two famous calligraphers Kojima Seisai (Fig. 101), who studied Yu Shih-nan,

樂毅論　　　夏侯泰初

世人以樂毅不時拔莒即墨為劣是以敘而

論之

夫求古賢之意宜以大者遠者先之必迂回

而難通然後已焉可也今樂氏之趣或者其

未盡乎而多劣之是使前賢失指於將來

不亦惜我觀樂生遺燕惠王書其殆庶乎

機合乎道以終始者與其喻昭王曰伊尹放

鏡中釋靈實集

畫彌勒像讚一首　并序

經稱彩畫佛像書去續事後素是知延續靡由

辮素即色方乃眼空妙矣夫誠言也正議大夫

使持節都督越州諸軍事越州刺史上柱國楊

祖本㲉心實相㲉圓伊銀錢之好宿諸寶瑟

之歡儀謝前夫人河東縣君柳氏婦德惟喪母

儀成性過隴之光陰不駿重壤之幽隔永纏歡

為圖濮州聖彌勒像一鋪并十事及家口供養

庶得上外兜率親承慈氏之顏下降閻浮載奉

菩提之會讚曰

87. *Section of* Shomu Tenno Shinkan Zasshu. *Miscellaneous calligraphy by Emperor Shomu; 731. Paper scroll; 27 × 2135 cm.*
Shoso-in, Nara.

聞衆天龍及又乹闥婆阿備羅迦樓羅緊那

羅摩睺羅伽人非人等聞佛所說頂礼佛足

歡喜奉行

入金剛場阤羅尼経巻一

歲次丙戌年五月川内國志貴譯内知識為十世父母及

一切衆生敬造金剛場阤羅尼経一部籍此善因往生净

土終成正覧

教化僧寶林

88. Section of Kongojo Darani Kyo. *Paper scroll; 686. Height, 27 cm.; length, 670 cm. Collection of Hiromi Ogawa, Kyoto.*

夫妙法蓮華経者蓋是総斯乃善合為一回之豊田七百返

壽轉成長遠之神藥若論迦釋如来應現氏長之大意看

守猷冥當氏経教循同歸之妙因令浮莫之大黒但衆生

宿殖善微神圖根銳以五濁斬於大檄六弊狙真慈眼率不

可聞一栗同黒之大理所以如来随時而宜勒誐慮亦三栗之

心犲疏使廠各趣之迦果泥氏未離復平説尤相勸同循成

以中道而襄賊猶以三曰朔果之相養育物微於是衆生應

年累月蒙教循行漸之益解生於王臧始之致大栗撟稱會如

未出世之大意是以如来即動方德之嚴軀開真金之妙口廣以

方善同歸之理使浮莫之大果妙法若外国云薩達摩眇咖

是絶廉之号法即氏経中而説一同一栗之法也言氏経中而説

一栗同果之法超於絶於昔日三栗同果之庿故稱如来蓮華

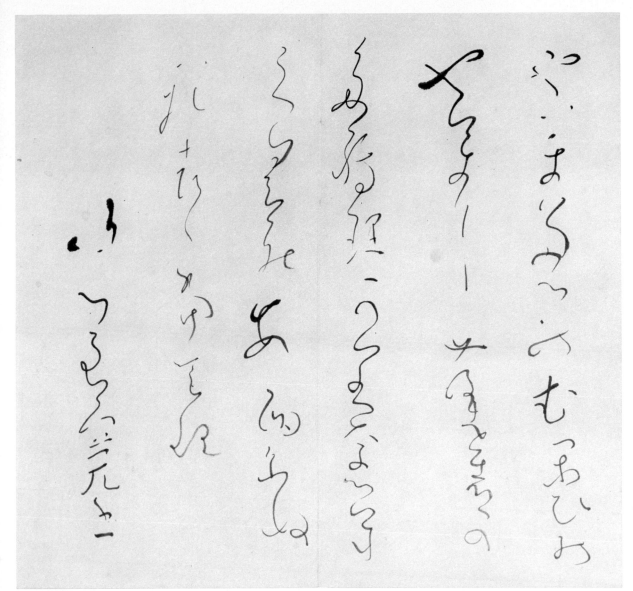

90. *Section of* Tsuki-no-Usagi Jo, *by Ryokan; 1821. Paper; 27.2 × 28.5 cm. Collection of Ryoji Kuroda, Kanagawa Prefecture.*

◁ 89. *Section of* Hokke Giso, *by Shotoku Taishi. Paper scroll; 615. Height, 25.5 cm. Imperial Household Collection.*

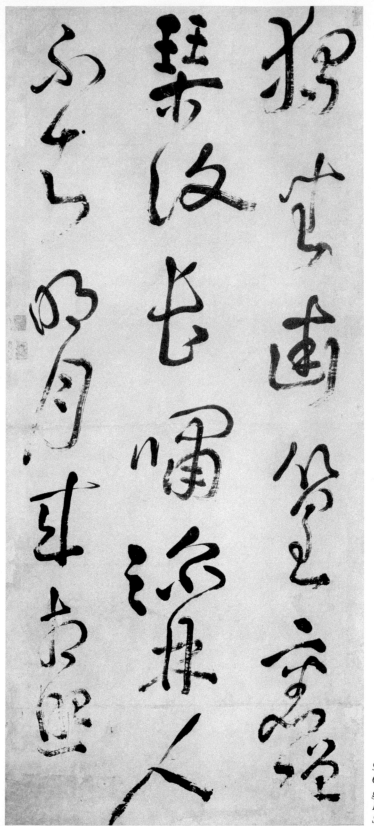

91. Poem by Wang Wei. Calligraphy by Ike no Tai-ga. Late eighteenth century. Paper; 130.9 × 57.5 cm. Shisen-do, Kyoto.

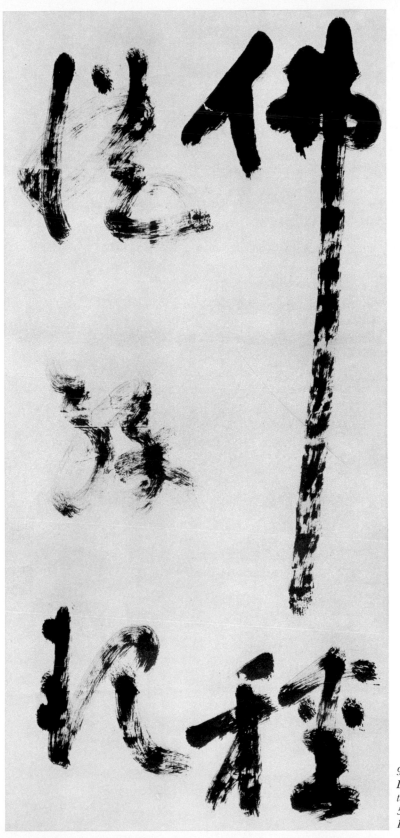

92. Buddhist maxim by Jiun. Late eighteenth to early nineteenth century. Paper; 109.5 × 51.2 cm. Collection of Ryoji Kuroda, Kanagawa Prefecture.

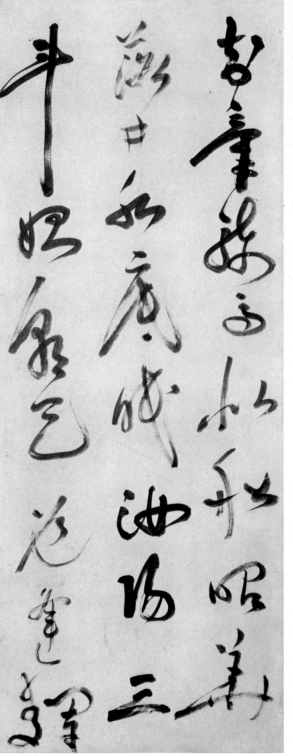

93. Poem by Tu Fu. Calligraphy by Jakugon. Eighteenth century. Paper-covered folding screen; each panel 134 × 51.3 cm. Unsho-ji, Tokyo.

94 (top left). Nan'endo Dotodai Mei. *Attributed to Tachibana Hayanari. Inscription on brass lantern; 816. Ink rubbing; height 45 cm. Kobuku-ji, Kyoto.*

95 (top right). Jingo-ji Shomei. *Bell inscription attributed to Fujiwara Toshiyuki; 875. Ink rubbing; height, 26.2 cm. Jingo-ji, Kyoto.*

96 (bottom left). Docho-ji Shomei. *Bell inscription attributed to Ono no Michikaze; 917. Ink rubbing; height, 35 cm. Eizan-ji, Nara.*

97 (bottom right). *Section of* Kokyo no Hi, *by Sawada Toko. Stele inscription of the* Classic of Filial Piety; *1787. Ink rubbing; overall size, 179 × 81 cm. Hayashizaki Bunko Library, Mie Prefecture.*

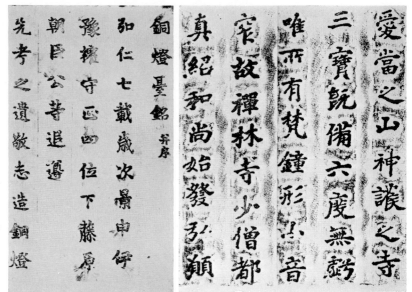

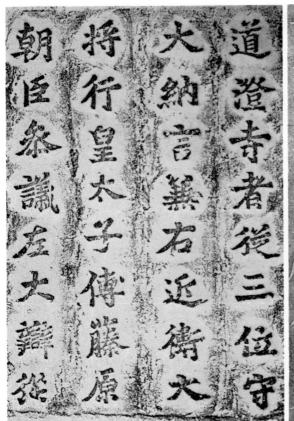

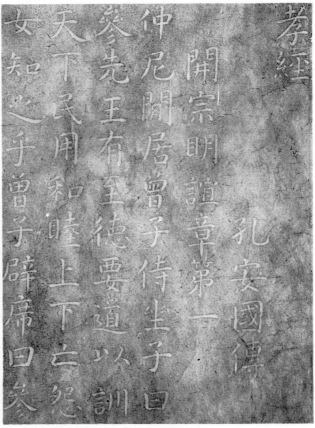

98 (top left). Section of Santai Hakurakuten Shikan (Poems by Po Chu-i in Three Scripts). Attributed to Ono no Michikaze. From the kaisho section. Tenth century. Paper scroll; height, 30 cm.

99 (top right). Chinese poem, by Maki Ryoko. Early nineteenth century. Paper, 126.3 × 43.4 cm.

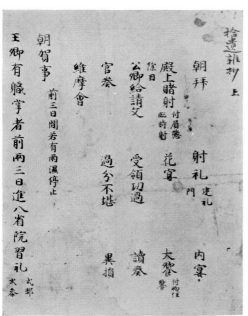

100. Hokuzansho (section of Vol. 3). Attributed to Fujiwara Kinto. Early eleventh century. Paper scroll; height, 29.5 cm. Maeda Ikutoku-kai, Tokyo.

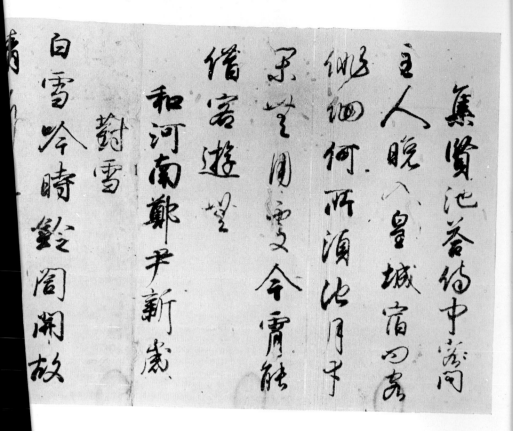

101. *Section of inscription by Kojima Seisai; 1835. Ink rubbing; overall size, 162 × 80.6 cm. Hofuku-ji, Tokyo.*

104. *Section of* **Hakurakuten Shikan** *(Poems of Po Chu-i), by Fujiwara Yukinari; 1018. Colored-paper scroll; height, 25.3 cm. Tokyo National Museum.*

105. *Section of* **Shukasho.** *Copybook by Son'en Shinno; 1343. Paper, 32.2 × 25 cm. Shoren-in, Kyoto.*

and Cho Sanshu, who studied Yen Chen-ch'ing, appeared. Meikaku Kusakabe was the first person to study the Chinese Northern Monuments and his work *Tanikawa Kiroku-hi,* a giant monument in a paddy field near the Nara Great Buddha Hall, is an unequalled ambitious work showing the influence of Cheng Tao-chao of Northern Wei. We mentioned in the chapter on *reisho* that Meikaku wrote many monument inscriptions. Representative of his *kaisho* is the *Okubo-ko Shindohi* (Fig. 102) at the Aoyama Cemetery in Tokyo. This and the *Mito-ko Shindohi* (Fig. 103) by Soken Nomura at Ryozen in Kyoto form a matchless pair.

A JAPANESE KAISHO

The specialist appreciation and study of *kaisho* in Japan started with the *karayo* calligraphers of the Edo period. The latter, however, labored under the handicap of a lack of good source materials and it was not until the Meiji period, when the study of Hokuhi calligraphy was taken up, that conditions improved. Nowadays reproductions of Sung-period and other old rubbings of all kinds of monument inscriptions, as also facsimiles of original, brush-written masterpieces, are easily available, and there is no scarcity of materials for the study of good *kaisho.*

Although *kaisho* has been used in Japan for a thousand years or so, it has always been based on Chinese models and has never developed uniquely Japanese characteristics. From the Heian period onward, it is true, *kaisho* of the *wayo* style did show a suggestion of qualities not to be seen in Chinese works, but these were not all that noticeable and the style can reasonably be regarded as a subtradition of T'ang *kaisho.* However, it is only natural

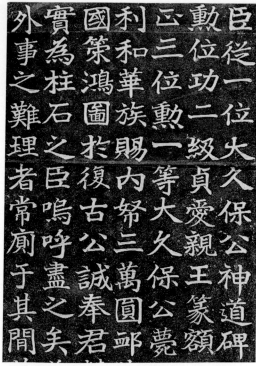

102. Section of Okubo-ko Shindohi. *Memorial inscription by Meikaku Kusakabe; 1910. Ink rubbing; overall size, 274 × 141 cm. Aoyama Cemetery, Tokyo.*

103. Section of Mito-ko Shindohi. *Memorial inscription by Soken Nomura; 1906. Ink rubbing; overall size, 275 × 97 cm. Ryozen, Kyoto.*

that Japan should have a *kaisho* style that reflects the Japanese character and culture. To attempt to apply Chinese models, unchanged, to the Japanese situation could only result in something forced. What is desirable is the development of an ideal Japanese *kaisho*—extracting and incorporating the essence of all good Chinese *kaisho* styles. There seems to be a tendency to prefer the plain, honest style of Hsu Hao to the lofty spiritual qualities of Ou-yang Hsun, the profound gentleness of Yu Shih-nan to the dry, robust effect of Yen Chen-ch'ing. But these preferences are not unchangeable.

Its use as the script for printed matter gives *kaisho* great importance, and being the script style that is most familiar to the Japanese in their daily lives, it deserves careful attention.

Gyosho: Semicu

THE TERM GYOSHO refers to a script style that is somewhat more cursive than *kaisho*. Its origins go back to the *reisho* scribe's script practiced in the Han and Wei periods. Today the *gyosho* of the Chin dynasty (fourth century A.D.) is considered to be typical. According to the degree of cursivization, three stages are distinguished: *seigyo*, *gyo*, and *gyoso*. *Seigyo* is between *kaisho* and *gyosho*, and *gyoso* is between *gyosho* and *sosho*. *Gyosho* does not strictly preserve the shapes of every dot and stroke. Avoiding sharp angles, it uses a soft, rounded technique, creating a feeling of warmth and openness.

One can see superb T'ang-style *gyosho* in such early Heian works as Kukai's *Fushinjo* (Figs. 32, 108) or Tachibana Hayanari's *Ito Naishinno Gammon* (Fig. 28) and *Nakatsukasa Iki* (Fig. 162). From the time of Emperor Uda in 894, since official embassies were discontinued and contact with T'ang China halted, a Japanese (*wayo*) calligraphy style began to develop.

Ono no Michikaze and Fujiwara Sukemasa of this period. The *Byobu Dodai* (Fig. 107) and *Chisho Daishi Shigo Chokusho* (Fig. 123; an imperial document awarding posthumously the new name and title Chisho Daishi to Enchin, the fifth head of Enryaku-ji) are works by Michikaze. The section of the *Santai Hakurakuten Shikan* (Fig. also attributed to Michikaze. It is a warm fleshy and powerful. There are example similar warm style in Wang Hsi-chih's *Sheng Chiao Hsu* (Fig. 18), and other *gyosho*

101. Section of inscription by Kojima Seisai; 1835. Ink rubbing; overall size, 162 × 80.6 cm. Hofuku-ji, Tokyo.

and Cho Sanshu, who studied Yen Chen-ch'ing, appeared. Meikaku Kusakabe was the first person to study the Chinese Northern Monuments and his work *Tanikawa Kiroku-hi,* a giant monument in a paddy field near the Nara Great Buddha Hall, is an unequalled ambitious work showing the influence of Cheng Tao-chao of Northern Wei. We mentioned in the chapter on *reisho* that Meikaku wrote many monument inscriptions. Representative of his *kaisho* is the *Okubo-ko Shindohi* (Fig. 102) at the Aoyama Cemetery in Tokyo. This and the *Mito-ko Shindohi* (Fig. 103) by Soken Nomura at Ryozen in Kyoto form a matchless pair.

A JAPANESE KAISHO The specialist appreciation and study of *kaisho* in Japan started with the *karayo* calligraphers of the Edo period. The latter, however, labored under the handicap of a lack of good source materials and it was not until the Meiji period, when the study of Hokuhi calligraphy was taken up, that conditions improved. Nowadays reproductions of Sung-period and other old rubbings of all kinds of monument inscriptions, as also facsimiles of original, brush-written masterpieces, are easily available, and there is no scarcity of materials for the study of good *kaisho.*

Although *kaisho* has been used in Japan for a thousand years or so, it has always been based on Chinese models and has never developed uniquely Japanese characteristics. From the Heian period onward, it is true, *kaisho* of the *wayo* style did show a suggestion of qualities not to be seen in Chinese works, but these were not all that noticeable and the style can reasonably be regarded as a subtradition of T'ang *kaisho.* However, it is only natural

102. *Section of* Okubo-ko Shindohi. *Memorial inscription by Meikaku Kusakabe; 1910. Ink rubbing; overall size, 274 × 141 cm. Aoyama Cemetery, Tokyo.*

103. *Section of* Mito-ko Shindohi. *Memorial inscription by Soken Nomura; 1906. Ink rubbing; overall size, 275 × 97 cm. Ryozen, Kyoto.*

that Japan should have a *kaisho* style that reflects the Japanese character and culture. To attempt to apply Chinese models, unchanged, to the Japanese situation could only result in something forced. What is desirable is the development of an ideal Japanese *kaisho*—extracting and incorporating the essence of all good Chinese *kaisho* styles. There seems to be a tendency to prefer the plain, honest style of Hsu Hao to the lofty spiritual qualities of Ou-yang Hsun, the profound gentleness of Yu Shih-nan to the dry, robust effect of Yen Chen-ch'ing. But these preferences are not unchangeable.

Its use as the script for printed matter gives *kaisho* great importance, and being the script style that is most familiar to the Japanese in their daily lives, it deserves careful attention.

Gyosho: Semicursive Script

THE TERM GYOSHO refers to a script style that is somewhat more cursive than *kaisho*. Its origins go back to the *reisho* scribe's script practiced in the Han and Wei periods. Today the *gyosho* of the Chin dynasty (fourth century A.D.) is considered to be typical. According to the degree of cursivization, three stages are distinguished: *seigyo, gyo,* and *gyoso. Seigyo* is between *kaisho* and *gyosho,* and *gyoso* is between *gyosho* and *sosho. Gyosho* does not strictly preserve the shapes of every dot and stroke. Avoiding sharp angles, it uses a soft, rounded technique, creating a feeling of warmth and openness.

One can see superb T'ang-style *gyosho* in such early Heian works as Kukai's *Fushinjo* (Figs. 32, 108) or Tachibana Hayanari's *Ito Naishinno Gammon* (Fig. 28) and *Nakatsukasa Iki* (Fig. 162). From the time of Emperor Uda in 894, since official embassies were discontinued and contact with T'ang China halted, a Japanese (*wayo*) calligraphy style began to develop.

Ono no Michikaze and Fujiwara Sukemasa are of this period. The *Byobu Dodai* (Fig. 107) and *Chisho Daishi Shigo Chokusho* (Fig. 123; an imperial document awarding posthumously the new name and title Chisho Daishi to Enchin, the fifth head of Enryaku-ji) are works by Michikaze. The *gyosho* section of the *Santai Hakurakuten Shikan* (Fig. 109) is also attributed to Michikaze. It is a warm style, fleshy and powerful. There are examples of a similar warm style in Wang Hsi-chih's *Chi Tzu Sheng Chiao Hsu* (Fig. 18), and other *gyosho* writings,

e.g., *K'uai Hsueh Shih Ch'ing T'ieh,* written with Wang's traditional "hidden tip" technique, and the similarity of these to Michikaze's *Santai Hakurakuten Shikan* allows us to ascertain that the latter originated from the same technique. However, the *gyosho* written by Michikaze is no longer a Chinese calligraphic style—it has a strong distinctly Japanese flavor. This is because Wang's methods were not accepted as they were, but were considerably altered to become a Japanese style. The *Shikaishi* (Fig. 106) by Sukemasa is already completely Japanized. Nearly seventy years later we can see in Fujiwara Yukinari's *Hakurakuten Shikan* (Fig. 104), *Honnoji-gire,* and *Hakushi Dankan* a totally Japanized *gyosho*; it is more gentle and alluring even than that of Michikaze. Yukinari was the founder of the Seson-ji school, and this style of *gyosho* was carried on by followers of the school. This became the root of Japanese-style *kanji,* and out of it the various branches and schools of calligraphy in Japan grew and flourished.

It is recorded in the *Jubokusho* by Son'en Shinno of the Seson-ji school that "one must first study *gyosho* because it is the middle way. After learning a little *gyo,* then one can study *kai* and *so.*" In China the order of study is *kai* and *gyo* then *so,* but in the traditional Japanese schools of calligraphy first *gyo,* then, once that is learned, *kai* and *so.* In Son'en Shinno's copybook, *Shukasho* (Fig. 105), one's first steps in beginning calligraphy are the soft techniques of *gyo.* The movement of the brush

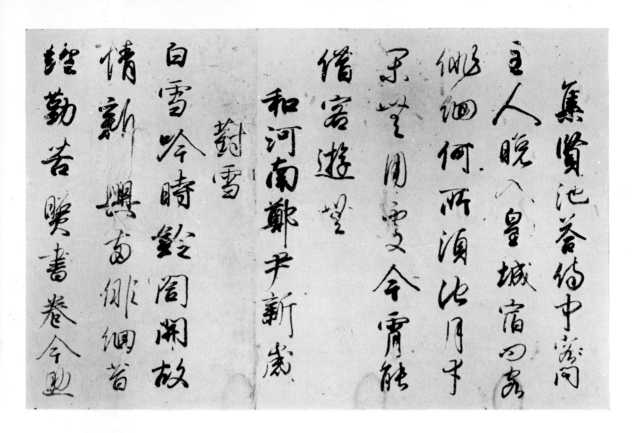

集賢池荅伯中翰
主人晚入皇城宿四家
似細何所須池月于
不登用雲今霄能
偕宮遊望
和河南鄭于新歲
對雪
白雪吟時鎔之閣開故
情新興高俳徊首
經勤苦興書卷今迊

104. Section of **Hakurakuten Shikan** *(Poems of Po Chu-i), by Fuji-wara Yukinari; 1018. Colored-paper scroll; height, 25.3 cm. Tokyo National Museum.*

105. Section of **Shukasho.** *Copybook by Son'en Shinno; 1343. Paper, 32.2 × 25 cm. Shoren-in, Kyoto.*

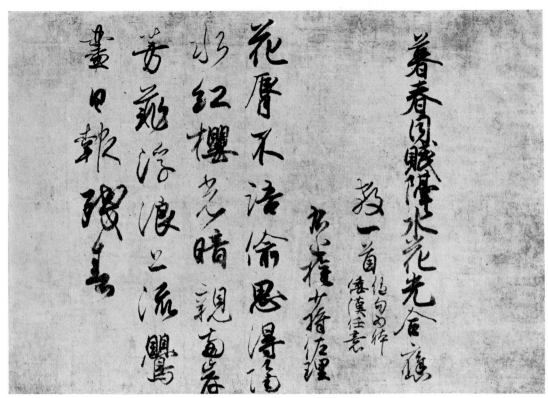

106. Shikaishi, by Fujiwara Sukemasa; 966–69. Paper, 32.2 × 45.1 cm.

is fat and round and smooth; even youngsters advance rapidly, able to write in a warm, full hand. This has been the traditional Japanese style of calligraphy ever since Michikaze's *Byobu Dodai* and *Shigo Chokusho*.

HARMONY OF KANA AND GYOSHO

Japanese is written using *kanji* mixed with *kana*. *Hiragana* were originally produced from grass *sosho* and they can be considered one type of *sosho*. Block *kaisho* is much too stiff a style to mix in with the more fluid, grassy *kana* style, but running *gyosho* makes quite an appropriate combination. When *gyo* or *sosho* is used with *hiragana* they fuse together and there is not the least feeling of unnaturalness. When Japanese is written in *kanji,* the use of *gyo* or *sosho* is only the natural course of events. We can surmise that the reason for having learners begin with *gyosho* lies somewhere in this naturalness. The Japanese literary arts tend generally toward peaceful simplicity, and in calligraphy too, the combination of *hiragana* and *gyosho* well expresses the harmonized tranquility typical of Japan.

In the Sekido transcription of the *Kokin-shu* (Fig. 152) there are, for example, quite a few *kanji* used in the *waka* poems. The style of the *kanji* is of course *gyosho*, blending perfectly with the connected *kana* style without the slightest awkwardness. One would never notice that the *kanji* in this work are Chinese.

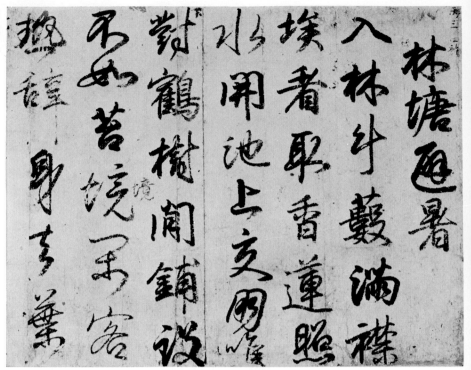

林塘逦暑
入林斗藪滿襟
埃看耳香蓮照
水開池上交囷僕
對鶴橫開鋪設
不如苦境一客
撼鐘身吉藁

風高雲畫日天朗昡
披之閱之如揭雲霧慧
惠止觀妙門頂戴僕各
云云佁屠之谷佃維
淒姥如如寠氣推舉攝
陷命躋攀彼巖限以山
弧不能東西之愚与我金蘭
及室山集會一霞量南仏
清大多因如茲建清懺報

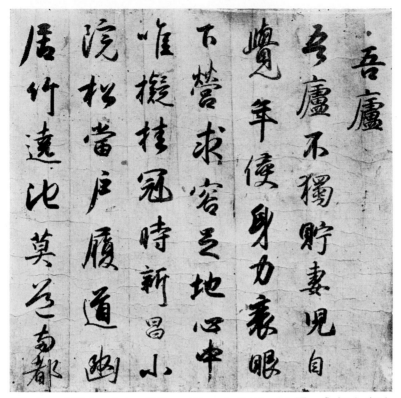

109. Santai Hakurakuten Shikan (Poems by Po Chu-i in Three Scripts). Attributed to Ono no Michikaze. From the gyosho section. Tenth century. Paper; height, 30 cm.

The harmonized beauty of *kanji* and *kana* was achieved with the *kana* of the Heian period. *Kaisho* was used for writing Chinese—with no *kana*—and the Japanese-style *gyosho kanji* were used for writing Japanese, that is, with *kana*. This is best understood by looking at the texts accompanying *e-maki* picture scrolls or the introductory remarks (*kotobagaki*) to poems, etc., of the Heian and Kamakura periods. This custom of *gyosho* joined with *kana* continued clear into the Edo period, when all the woodblock-printed books connected with literature were written in this method. Today, vestiges of this tradition are to be seen only in the texts of Noh plays.

The fact that the most suitable *kanji* script styles for use together with *hiragana* are *gyosho* and *sosho* throws an interesting light on the nature of Japanese calligraphy, or rather Japanese scripts in general.

DICTIONARIES OF GYOSHO In Japan there are dictionaries that give solely *gyosho* characters. One of these is the *Gyosho Ruisan* (12 vols.; 1833) edited by Seki Kokumei and his son Shiryo. The characters were taken from copybooks of various periods and arranged according to the number of strokes of each *kanji*, with the name of the writer below each character. Ichikawa Beian's *Kaigyo Waihen* (15 vols.; 1855) is a combined dictionary for *kaisho* and *gyosho*; it is also a useful dictionary for *gyosho* studies. This type of dictionary is another indication that Japanese writing customs differ from those of China.

CHAPTER EIGHT

Sosho: Cursive Script

ORIGINS OF SOSHO *Sosho,* which originated in China during the Han dynasty, is a contracted note-taking form of the scribe's *reisho* used at the time. Occasionally we find cursivized *tensho* characters too, but strictly speaking, *sosho* is related only to *reisho*. It is thought that the breaking-wave style, in which the ends of some strokes sweep up to the right, was characteristic of early *sosho*, as it is of *reisho*. Today examples of this are to be found on the inscribed wood and bamboo strips (Fig. 10) from the Han dynasty, which may be designated "old *sosho*." There is another ancient style called *shoso,* which is also a type of *sosho* characterized by the breaking-wave style and probably a variant of old *sosho* (Fig. 9). *Sosho* subsequently became a distinct script style, perhaps through a process of gradual emphasis of the breaking-wave element.

Toward the end of the Han period, a form of *sosho* evolved that was written slowly, character by character, in contrast with the fast, abbreviated *sosho* that had been used until then. This was probably a result of the realization of the value of *sosho* as a beautiful form of writing. It became an independent script style called *dokuso,* or unconnected *so,* and is to be seen in works like Wang Hsi-chih's *Shih Ch'i T'ieh* (Fig. 17). For a long time after, this type of *sosho* was carried on by those upholding the Wang Hsi-chih tradition. Thereafter, aside from the *dokuso* there evolved the "connected" style, or *remmentai* (Fig. 19). This style has also been common since the appearance of copybooks of calligraphy by the two Wangs. The unconnected and connected styles of the Wangs continued into the T'ang period, when the connected *remmentai* further developed into the "wild grass" *kyoso* of Chang Hsu and Huai Su (Fig. 20).

In summary, there are "old *sosho*" and *shoso,* and there are the unconnected *dokuso* and connected *remmentai,* the latter of which also includes wild grass *kyoso.* While showing stylistically creative alterations in later times, they evolved into diverging variations.

SOSHO IN JAPAN The study of *sosho* in Japan came of course after the introduction of Chinese characters, but there are no specimens from the Yamato period (300–710), and we cannot be sure of the exact date of introduction. A writing technique had already been developed by the Asuka period, and some exquisite works survive today. Such work is to be seen here and there in the *Hokke Giso* (a Lotus Sutra commentary) by Shotoku Taishi (Fig. 89), a mature piece that does not fare badly even in comparison with top-ranl Chinese calligraphy.

Man'yo-gana, the *kana* of the *Man'yoshu,* are actually *kanji* in *kai, gyo,* and *so* styles that were used as phonetic symbols. The oldest works of this kind are the two *Man'yo-gana Monjo* (documents in *man'yo-gana*) in the Shoso-in Repository. The style is a contracted, smoothed down *sosho* (Fig. 129)

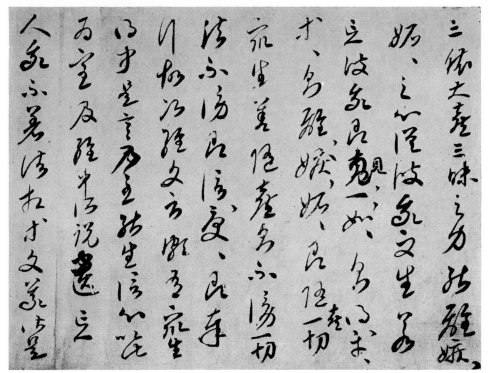

110. *Section of* Kongo Hannyakyo Kaidai, *by Kukai; 813. Paper; height, 27.8 cm. Kyoto National Museum.*

highly reminiscent of the unconnected style seen in Wang Hsi-chih's *Shih Ch'i T'ieh* (Fig. 17). Also, because of the T'ang- and Chin-style calligraphy practiced in the Nara period it is justifiable to see a resemblance between grass *kana* styles and those of Wang's calligraphy. The method of abbreviating the characters in these two documents is very similar to the Wang technique used in the T'ang dynasty.

In the same volume as these two *man'yo-gana* documents is another document that has forty-six characters written in T'ang-style *sosho* with their *kaisho* equivalent written beneath each one. This example shows that a T'ang-style *sosho* was widely studied in the Nara period.

In the early Heian period, Kukai went to China and studied T'ang-style *sosho*. He copied out the

Shu P'u (687) by Sun Kuo-t'ing of T'ang, who was in the Wang tradition. Kukai's *Kongo Hannyakyo Kaidai* (a discourse on the Diamond Sutra; Fig. 110) is also in a style belonging to the tradition of the *Shu P'u*. The *Shu P'u* copy in the imperial possession (Fig. 112), the inscriptions on the portraits of the Seven Shingon Patriarchs, and the entry for November 15, 812 in the *Kanjoki* all reputedly by Kukai, are all in the same style. The closest Chinese example along these lines is the *Sheng Hsien T'ai Tzu* pillar inscription by the empress Tse T'ien-wu in 699.

Also attributed to Kukai is a large-charactered *sosho* copy of *Tsuo Yu Ming* by Ts'ui Tzu-yu of Later Han (Fig. 111). It is an extraordinary work, technically skilled, with a kind of bursting energy that exhausts the technical subtleties of the tradi-

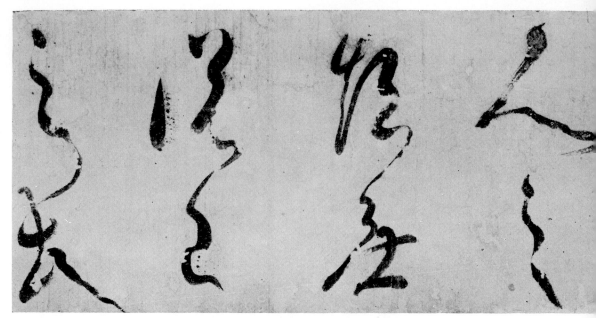

111. Fragment of Ts'ui Tzu-yu's Tsuo Yu Ming, *attributed to Kukai. About early ninth century. Paper, 28.5 × 71.4 cm. Hoki-in, Mount Koya, Wakayama Prefecture.*

tionalist school. Kukai himself mentioned that he studied "crazy grass writing," and he may have been referring to this type of work. The various "new wave" T'ang styles of writing that Kukai learned held great sway over Japanese calligraphy, and constitute the foundation of *sosho* in Japan.

Further, another work reputed to be Kukai's is the *Shinsen Ruirin Sho* (Fig. 113). This is actually not by Kukai but it is an excellently done, genuine *sosho* piece by a calligrapher of the T'ang traditionalist school, this kind of fine *sosho* calligraphy having been introduced in the early Heian period. This, along with the much later imported *Classic of Filial Piety (Hsiao Ching)* by Ho Chih-chang is in an excellent, correctly written T'ang *sosho* not to be seen on the mainland today.

One more focal point in Heian-period *sosho* is the *Hakurakuten Shiku* (Poems of Po Chu-i; Figs. 26, 117) reputedly by Emperor Daigo (897–930). At a glance the script looks like the work of a drunk, with a splattering, uninhibited style on a grand scale, reminiscent of the wild grass of the T'ang calligrapher Chang Hsu. It is said that Chang Hsu would get drunk, and while shouting at the top of his voice would slap huge *sosho* characters on anything that came to hand—pots, clothes, anything. It is also said that at times he would soak his hair in ink and write with it. Huai Su, a monk who took up this technique, wrote in a similar *sosho* style, and this is the so-called wild grass. *Poems of Po Chu-i* undisputedly matches this style. The final stroke of the character *shu*, meaning "wine," is taken upwards like a dragon's tail. This is a special device found in Chang Hsu's calligraphy, called *che ch'ai ku* ("broken hairpin"). The similarity could not be a coincidence. We can take it as an unusual example of Chang Hsu's technique of "wild grass" entering Japan.

Other examples of Heian *sosho* are found on the brocades and silks that carry mainly the poems of Po Chu-i and which are attributed to Ono no Michikaze and Fujiwara Sukemasa. *Ayaji-gire* (Fig.

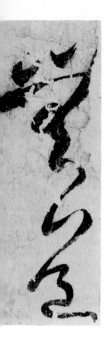

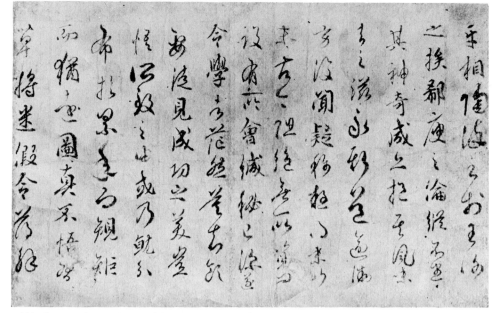

112. *Section of transcription of Sun Kuo-t'ing's* Shu P'u *attributed to Kukai. Early ninth century. Paper, 29.3 × 45.8 cm. Imperial Household Collection.*

128), beautiful figured silk occasionally decorated with colored flowers or birds, as in the *Sokanjo* (Fig. 126), is one kind. The other type, *kinuji-gire,* is usually written on plain silk. The *sosho* on these is a refined style with a gentle flowerlike charm. Writing these poems of Po Chu-i in *sosho* for one's pleasure was probably learned from the custom practiced among the Chinese literati. The brushwork of this medium closely resembles the *Sheng Mu T'ieh* and *Shih Yu T'ieh* by the above-mentioned Huai Su, which also cannot be considered a coincidence. It is not unnatural that there should be styles like Chang Hsu's and Huai Su's in Japan, and we can see that this is one more type of work stemming from the *sosho* styles of the T'ang period. The *sosho* popularity at the T'ang court probably also played an important background role in the development of *kana.*

The latter half of the Heian period, due to the cessation of relations with China, was completely given over to the pursuit of *kana.* During the Kama-

kura period however, Zen monks who had gone to Sung China reintroduced the calligraphy of the mainland. The *Kan'enso* (Fig. 127) written by Shunjo, the founder of the Sennyu-ji temple in Kyoto, is a fine *sosho* work in the style of Huang Shan-ku. Its technical subtlety is said to have amazed the courtiers of the day, and even today it is thought to be a superb work. The Zen monks of the Rinzai branch in the latter part of the Kamakura period were also versed in *sosho.* Among them the naturalized monk Issan Ichinei (Fig. 138) and Muso Soseki, the founder of the Tenryu temple in Kyoto, were particularly skillful.

However, the calligraphy of the Zen monks in general is a technically free style that values Zen ideals highest, its natural spontaneity contrasting with that of the technique-ridden specialist. Ikkyu Sojun, prominent in the Muromachi period, favored a rough bamboo-fiber brush and wrote strange, unorthodox calligraphy. This style (Fig. 134), brimming with vitality, represents his own

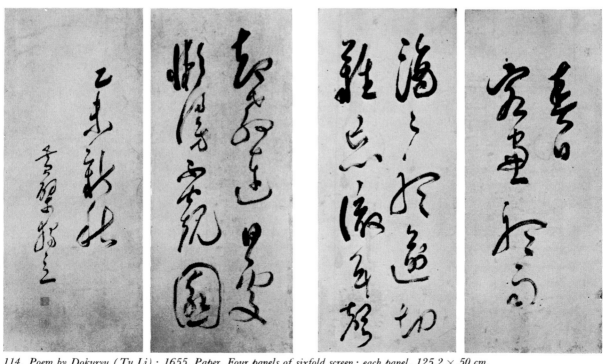

114. Poem by Dokuryu (Tu Li); 1655. Paper. Four panels of sixfold screen; each panel, 125.2 × 50 cm.

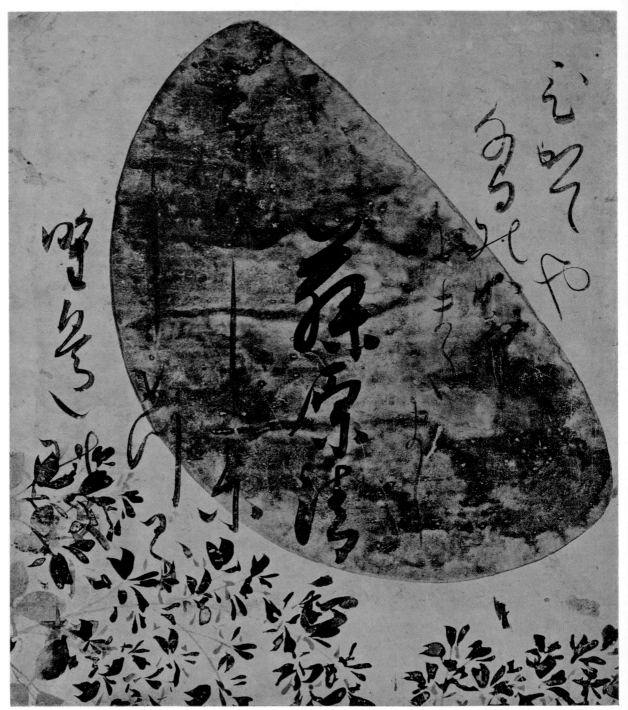

119. Section of Sanjurokkasen Shikishi, *by Shokado Shojo. About early seventeenth century. Paper decorated in gold and silver; 20 ×
17.6 cm. Collection of Hikotaro Umezawa, Tokyo.*

120. *Section of* Wakan Roei Shikishi Jo, *by Konoe Nobutada. About 1600. Paper decorated in gold; 21.2 × 17.8 cm. Yomei Bunko Library, Kyoto.*

121. Genji Monogatari Emaki *(Tale of Genji Picture Scroll)*, kotoba-gaki *of "Kashiwagi" section. Attributed to Fujiwara Korefusa. Twelfth century. Decorated paper; height, 21.9 cm. Tokugawa Reimei-kai Collection, Nagoya, Aichi Prefecture.*

122. *Section of* Koya-gire *(an incomplete transcription of the* Kokinshu*), attributed to Ki no Tsurayuki. About mid-eleventh* ▷ *century. Paper decorated with mica paste; originally in scroll format. Height, 25.8 cm. Goto Art Museum, Tokyo.*

ほのゝまほろたまほろ
あわらのもころ

あのうらほゝめのまゝらほと

路ふのちほひまる

まろのちほひまる
さのほゆき

そてちよむまらみのへほわる

おほろたまらのとやしむ

天台座主少僧都法眼和尚位圓珎

右贈傳法師大和尚位□智證大師

勅慈雲秀穎仰則

弥高清水清流酌之

寧盡故天台座主

少僧都圓珎戒珠

□摩慧性有幽渡

冬夜

一盞寒燈雲外夜殘盃溫䗥雪中春 白

四時牢落三分減万物蹉跎過半凋 醍醐御製

床上巻収青竹簟更中用出白綿衣 菅

冬
初冬

十月江南天氣好可憐冬景似春華 白

うらゝゝもゝは
みゝすれゝけそらゝ
ゝすれゝよゝゝす
すれゝてよゝゝ
りみゝふりゝ
むゝ

124. *Two pages of the* Detcho-bon Wakan Roei-shu, *attributed to Fujiwara Yukinari. About mid-eleventh century.* Karakami-
paper in detcho glued binding; each page 20 × 12 cm. Imperial Household Collection.

◁ 123. *Section of* Chisho Daishi Shigo Chokusho, *by Ono no Michikaze; 927. Colored-paper scroll; 28.7 × 154.9 cm. Tokyo
National Museum.*

125. Waka-shikishi, by Hon'ami Koetsu; 1606. Waka on gold- and silver-decorated paper; 20 × 18 cm. Yamato Bunkakan, Nara.

126. Hakushi Monju Dan-kan *(Fragment of Anthology of the Works of Po Chu-i), attributed to Ono no Michikaze. About tenth century. Figured silk; height, 27.6 cm. Maeda Ikutoku-kai, Tokyo.*

Ogyu Sorai (Fig. 116), and Cho Tosai (Fig. 171) were the experts at *sosho*. At the end of the Edo period Ichikawa Beian (Fig. 175) and Nukina Kaioku (Fig. 176) appeared. Beian prized the work of the Sung calligrapher Mi Fu and also studied Ming and Ch'ing calligraphy. He brought the "reformist" tradition to maturity. Kaioku, by valuing the old T'ang works and studying the techniques of the Chin and T'ang periods, became the leader of the "old" school.

DICTIONARIES OF SOSHO The intelligentsia of the Edo period liked *sosho*, and in line with this preference, aside from the copies of *Senjimon* (Thousand Character Essay), which showed each script, there were a fair number of dictionaries printed in *sosho* alone. (A number of these important works are illustrated on the foldout facing page 73.) The earliest of these is the *Sosho Inne* (5 vols.; early Edo period) by Chang T'ien-hsi of the state of Chin in north China (1122–1234). The next, not dictionaries, are *Ri Takugo Sensei Hitsu Shinkan Soji Senka Shi* (2 vols.; 1660), and *Sosho Yoryo* (Essentials of *Sosho*; 5 vols.; 1664). The latter is a printed edition of a scroll of *sosho* copied by T'ang masters. It has a preface by a man named Cheng I-ch'i. The characters are classified according to their components. There are sections on variant forms, unusual characters, characters whose *kaisho* forms are the same but having different *sosho* forms, etc. The above dictionaries are relatively early reprints of Chinese printed editions.

Other works are *Sosho Enkai* (4 vols.; 1675; by Ide Gakei); *Sorokanshu* (22 vols.; 1696; compiled by the Mito Shokokan), which has 6,070 *kaisho* characters and 49,500 *sosho* characters (republished in 1913 as *Sosho Daijiten*); and the *Wakan Soji Ben* (1734), by the Kyoto calligrapher Kuwabara Kudo. These works also arrange the characters according to the number of strokes and the component elements, and included too is a poem relating to the history of characters, the *Shotai Enkaku no Uta*. It is thought that these dictionaries were used as copybooks by Ike no Taiga and his contemporaries, and this tells us much about the provenance of Taiga's style. The *Sosho Juttai Senjimon,* compiled by Izumi

Hitto in 1745, has each character of the *Thousand Character Essay* in ten different styles of *sosho*. Hitto is said to have studied with Den Kanran and Niioki Mosho, and is known for his paintings and calligraphy. There is the *Sosho Hoyo* (5 vols.; 1817) compiled by Wakita Jun, with prefaces by Yamamoto Hokuzan, Minagawa Kien, and Nakai Todo, and an epilogue by Ono Kunzan. It arranges the characters according to their components and the writer of each character is indicated. There is also the *Soi* (4 vols.; 1817) compiled by Shinozaki Santo and arranged by the four tones of the Chinese language, with a preface by Koga Seiri. The *Sojii* (12 vols.; 1829), compiled by Shih Liang of the Ch'ing dynasty, also arranges its characters accord-

127. *Section of* Kan'enso, *by* Shunjo; *1219. Scroll of wax-decorated paper; 40.8 × 293 cm. Sennyu-ji, Kyoto.*

ing to the number of strokes, and gives the writer of each character. Its useful contents skillfully arranged, it became widely circulated in the Meiji period. The *Sosho Kaku* (2 vols.; 1849), by Hoshi Kendo of Aizu, has titles written by Togawa Ren'an and an introduction by Otsuki Bankei. Arranged by the number of strokes, it is a very handy dictionary with sections on variants, misleading characters, etc. *Soso* (12 vols.; 1854), edited by Senoo Shozo, extracts the essentials of *Sorokanshu* (see above) and has an introduction by Koga Sakei. There were of course many other dictionaries published.

On the whole, the data on the *sosho* dictionaries of the Edo period needs reexamination and there is material that has been misclassified. Moreover, the crudity of the woodblock prints for the most part limits them to merely indicating the route of the brush. Inaccuracy is a problem here. Even so, since these were the materials at hand for the scholars of the time, they are useful reference works for Edo *sosho*. Even in the Meiji period the same kind of publications appeared, but they were often no more than an extension of the Edo works. Only in the modern period (since 1912) has it become possible to make dictionaries of *sosho* and other script styles based on reliable models. But most of the *sosho* characters in these are still based on the copybooks or dictionaries, and we can expect more accurate dictionaries to be produced.

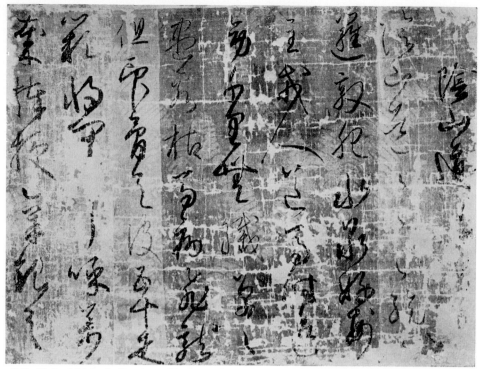

128. Hakushi Monju Dankan *(Fragment of Anthology of the Works of Po Chu-i), attributed to Ono no Michikaze. About tenth century. Figured silk; 27 × 32 cm. Yomei Bunko Library, Kyoto.*

THE AESTHETICS OF SOSHO

Sosho developed originally as an abbreviated style for writing quickly, but in certain aspects it is endowed with an aesthetic nature. Although it is difficult to read, its inherent flexibility of form is most suited to artistic works, and many exquisite works have been produced in it. Furthermore, *sosho* being the parent from which Japan's own *hiragana* were born, its ties with Japanese calligraphy are deep, and much excellent Japanese calligraphy is in this script.

The *sosho* that is prized today is not that of the traditional Confucianists of the Edo period; it is rather that of radical monks and literati like Jakugon (1702–71; Fig. 93), Jiun (1718–1804; Fig. 92), Ike no Taiga (Fig. 91), and Ryokan (1758–1831; Fig. 90) because they grasped the essential aesthetic nature of *sosho*. From Meiji to the present there has been a strong tendency to study the seventeenth-century Ming and Ch'ing calligraphers Chang Jui-t'u, Ni Yuan-lu, Hsu Yu, Fu Shan, and Wang Tuo, whose *sosho* shows the richest creativity.

The feeling is very strong that there is a deep bond between Japanese calligraphy and *sosho*. Japanese art as a whole is said to be characterized by a *sosho* kind of feeling. We can see now that this is quite literally true of Japanese calligraphy.

Hiragana

MAN'YO-GANA
TO HIRAGANA

Man'yo-gana are *kanji* used to represent the syllables of the Japanese language. In this writing system, every Japanese syllable was assigned a number of *kanji*, any of which could be used to represent that syllable. Thus in the early stages of its development, the *kana* system was quite complicated. The style of early *kana* as in the two *Man'yo-gana Monjo* (*Man'yo-gana* documents; Fig. 129), the *Kara-ai no Uta* (Fig. 142), the *Bussokuseki no Uta* pillar (Fig. 132), the graffiti of the five-story pagoda at Horyu-ji, and other works is all *kaisho*, *gyosho*, and *sosho* borrowed from China. In the early Heian period the *Aritoshi Moshibumi* (867; Fig. 133) is written in the same style of "grass *kana*" as the *Man'yo-gana Monjo*. It is thought that *kana* had already developed at this time, but we have no certain proof. In a copy of Ki no Tsurayuki's *Tosa Diary* copied by Fujiwara Sadaie (1162–1241), and in one of Ono no Michikaze's letters included in the *Naniwa Jo* (1819; a copybook printed from woodblocks carved by Morikawa Chikuso), there are already passages in connected *hiragana*. A scrap of paper recording the date of birth of Chonen (938; Fig. 130), founder of Shoryo-ji temple in Saga, Kyoto, and believed to have been attached to his umbilical cord, has some beautiful *hiragana* written on it. The *Kana Shosoku* (*kana* letter; 966; Fig. 145) on the back of the *Kokuzo Bosatsu Nenju Shidai* in the Ishiyama-dera, Shiga Prefecture, and the *Mido Kampaku Michinaga Nikki* (diary of the regent Fujiwara Michinaga; 1004; Fig. 146), also have passages of connected *hiragana*. The *Kana Shosoku* (996–1001; Fig. 153) on the back of the *Hokuzansho* is written in a polished, flowing *hiragana*. These reliably dated materials enable us to trace the main stages in the development of *hiragana*.

With the arrival of *hiragana*, *kana* separated into three types—*onokode* (men's writing), *so* (*sosho*), and *onnade* (women's writing). Men's writing consists of the *kaisho* and *gyosho* forms of *kanji*, *so* is *sosho kanji*, and women's writing is *hiragana*. Since Chinese studies were the special province of men, they concentrated on *kaisho* and *gyosho*. As women specialized in *waka* literature instead of Chinese studies, they came to use *hiragana*, which they developed by "softening" *kanji* to fit the graceful, courtly feeling of *waka* poetry. Eventually men also came to use "women's writing." On reflection it seems reasonable enough to consider *kaisho* and *gyosho* as suitable for men, and *hiragana* for women, with *so* as an intermediate style. But I have never heard of such a distribution of script styles according to sex in China. *Kaisho* there was a formal style whereas *sosho* was an abbreviated style used for a feeling of freedom or escape; this was the only division between the two. In the Nara period, the Chinese usage was still maintained in Japan. Empress Komyo was copying out Wang Hsi-chih's *Yueh I Lun* in small *kaisho* (Fig. 86). Evidently, then, *kaisho* was not limited to men at this time. The male-female distinction probably came about

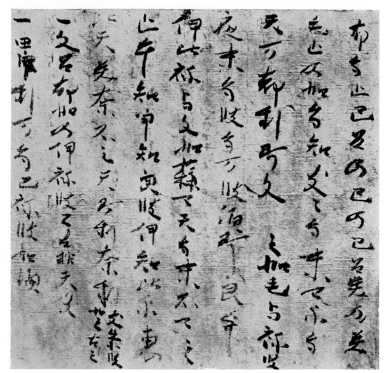

129. *Section of* Man'yo-gana Monjo *(*Man'yo-gana *Documents). About 762. Paper, 29.1 × 30 cm. Shoso-in, Nara.*

130. *Paper scrap bearing Chonen's date of birth; 938. Length, 14 cm. Seiryo-ji, Kyoto.*

in the Heian period when *hiragana* was refined into an unexcelled, graceful form in the hands of sensitive court ladies.

THE BEAUTY OF HEIAN KANA

Let us consider a little more deeply the underlying characteristics of the beauty of Heian *kana*. Originally characters developed basically in the direction of concise, speedy writing. Of the three styles of early *kana* (*man'yo-gana*)—kaisho, *gyosho,* and *sosho—sosho* most fits this principle. And by developing this script style further in the same direction, *hiragana* were produced.

Moreover, in addition to being a refinement of the simple, soft beauty of *sosho, hiragana* received their final polish from the beautiful sentiments of women writing in the environment of the Japanese climate and the Japanese national character, more specifically, among the nobles of the Heian court. The love letters exchanged between men and women—their elegant, gentle nobility; their neat, pure form; the alluring, elegant beauty of the natures of their writers—brought into being this peerless script—*hiragana*. Their beauty is parallel to that of the *waka* poetry of the time.

The second characteristic of the beauty of *kana* is to be found in *remmentai*. This connected style also occurs in China, but when *kana* are written in *remmentai*, a fine line is used, producing threadlike subtleties of technique with a lyrical beauty and pure refinement unseen in that country.

I have already mentioned that in the *kana*-usage

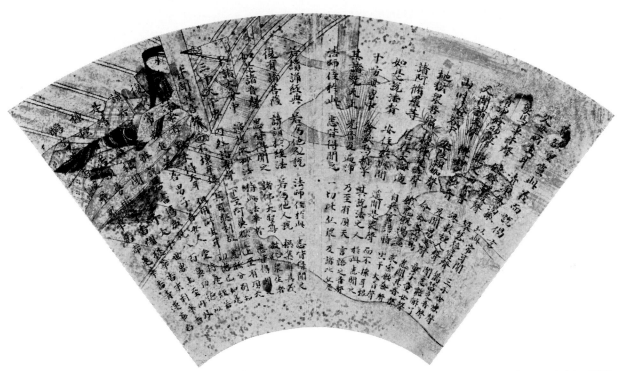

131. Section of Semmen Hoke-kyo *(Lotus Sutra copied on fan-shaped paper). Twelfth century. Decorated paper; height, 25.2 cm. Shitenno-ji, Osaka.*

system of this time many characters could be used to represent the same sound. Consequently there was room for considerable graphic variation, and judicious choice of the *kana* character to be used for any given syllable gave added beauty to the *remmentai* style. And while grammatical rules restricted somewhat the choice of *kana*, the practical application of the new script was wide, allowing considerable freedom in heightening the beauty of the connected style.

Examples of *kana* among which some *kanji* have been interspersed, such as the *Shunshoan Shikishi* (Fig. 56) and the *Sekido* manuscript of the *Kokinshu* (Fig. 152) still exist from the Heian period. In writings from the end of this period, as seen in the Gen'ei manuscript of the *Kokinshu* (Fig. 150),

kanji were used in greater numbers. The disposition of *kanji* and connected *kana* is truly beautiful, the *kanji* having been assimilated to the Japanese feeling so thoroughly that one is not conscious that *kanji* came from China.

During the Heian period *kana* was intimately linked to *waka* court poetry. This form of poetry emerged in the Nara period, the literal meaning of the name being "Japanese poetry," as opposed to *kanshi*, or Chinese poetry. Many of the works written in *kana* are either anthologies of *waka* or include some *waka*, for example, *Man'yoshu, Kokinshu, Wakan Roei-shu,* etc. The natures of *waka* and *kana* have important points in common, and we can derive a knowledge of the essence of *kana* from that of *waka*.

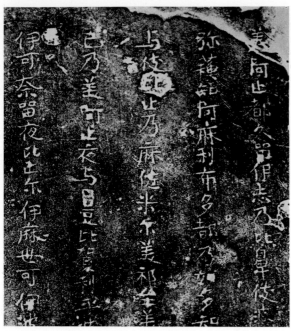

132. *Section of* Bussokuseki no Uta no Hi. *Poem inscribed on stele. About 770. Size of inscription, 146 × 41 cm. Ink rubbing. Yakushi-ji, Nara.*

133. *Section of* Aritoshi Moshibumi; *867. Paper scroll, 30 × 45.5 cm. Tokyo National Museum.*

KANA COMPOSITION In the format of *kana* writings, too, great skill is shown. When writing *kanji,* each character is written within an imaginary square frame. But *kana* are usually written in connected form, and this gives *kana* works the same kind of beautiful freedom of disposition of characters and overall composition that can be seen in paintings. This is partly the result of the elegantly graceful, *sosho*-like nature of *kana,* but at the same time there must have been a conscious effort to create objects beautiful as applied art.

The irregular positioning of characters and lines takes various forms. For example, the characters may be written in slanting lines, in place of the normal vertical ones; or one line may partially overlap with the previous line; or the lines may be stacked so that their tops do not align, etc. The *Sunshoan Shikishi* (Fig. 56), *Tsugi-jikishi* (Fig. 57), *Gen'ei-bon* manuscript of the *Kokinshu* (Fig. 150), *Masu-jikishi* (Fig. 144), and the *kotoba-gaki* (introductory and explanatory passages) of the *Sanjuroku-nin Shu* (Anthology of the Thirty-six Poetic Geniuses) and the *Genji Monogatari Emaki* (Tale of Genji Picture Scroll; Fig. 121) are examples of various line arrangements.

The blank spaces created by this kind of writing give the same kind of effect as a painting. The *waka* poem of the *Masu-jikishi* shown in Figure 144 suggests visually the effect of the moon rising through

134. *Section of Buddhist verse. Calligraphy by Ikkyu Sojun. Fifteenth century. Paper; each column, 133.4 × 41.4 cm. Shinju-an,* ▷
Daitoku-ji, Kyoto.

135. Section of Daikaku-ji Ketsuge Shumeitan, *by Son'en Shinno; 1335. Paper scroll; height, 43 cm. Imperial Household Collection.*

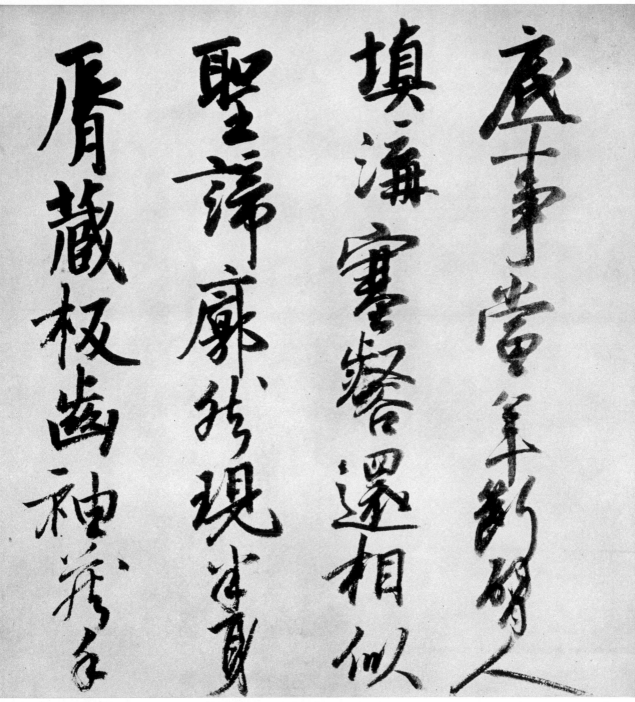

136. *Inscription on painting of the Zen patriarch Bodhidharma, by Emperor Hanazono. Early fourteenth century. Paper, 40.6 × 42.1 cm. Chofuku-ji, Kyoto.*

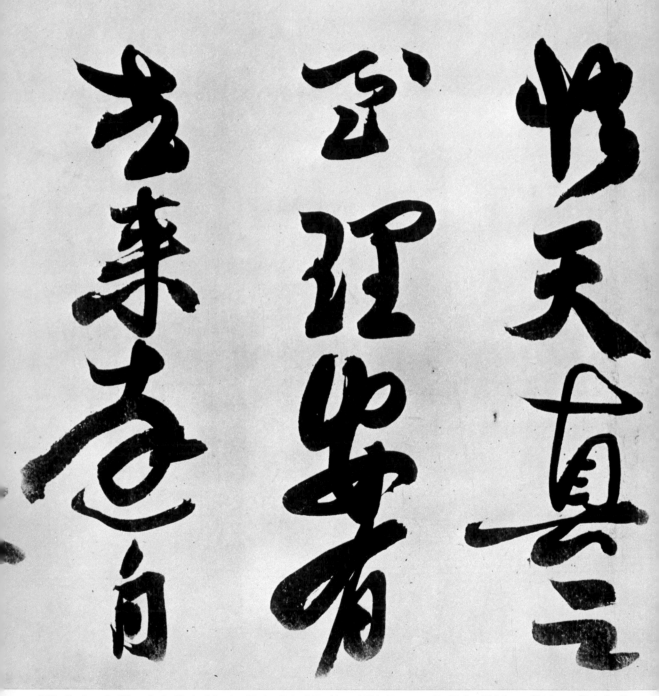

137. *Section of calligraphy by Shuho Myocho (Daito Kokushi). About 1334. Paper scroll, 32.8 × 835.9 cm. Shinju-an, Daitoku-ji, Kyoto.*

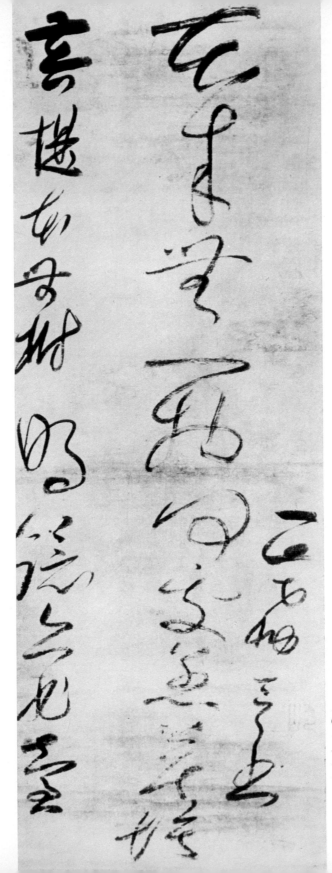

138. Buddhist verse by the Chinese Zen master Hui-neng (638–713). Calligraphy by Issan Ichinei (I-shan I-ning). About early fourteenth century. Paper, 87.8 × 26.8 cm. Collection of Toyohiko Inui, Hyogo Prefecture.

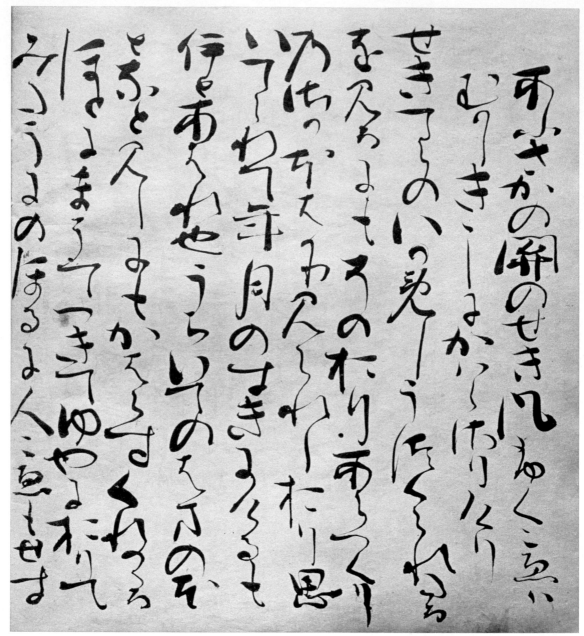

139. Section of Sarashina Nikki *(Sarashina Diary), transcribed by Fujiwara Sadaie. Late thirteenth century. Paper, 16.3 × 14.5 cm.; sewn binding. Imperial Household Collection.*

140. Hino-gire, *by Fujiwara Toshinari. Fragment of* Senzai Waka-shu, *an anthology of* waka *compiled by Toshinari.* ▷ *About 1188. Paper, 22.5 × 15.7 cm.; originally sewn binding.*

恋哥三

いゝしらぬ

　　　　藤原實方朝臣

ひきもやらましことありてふ

つらしともなくやうちよわひ

しらゝかゝ（…）もゝもしぬ

かくりかきまさりけるよ（…）

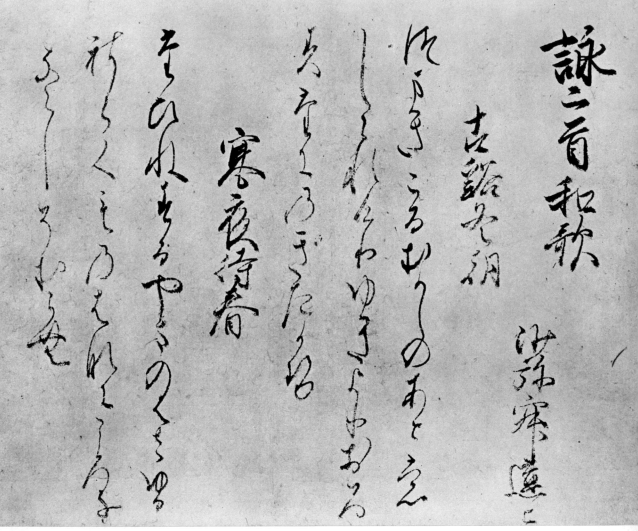

141. *Section of* Kumano Kaishi, *by the Buddhist priest and* waka *poet* Jakuren. *Two* waka; *about 1200. Paper, 30 × 43.5 cm.*
Yomei Bunko Library, Kyoto.

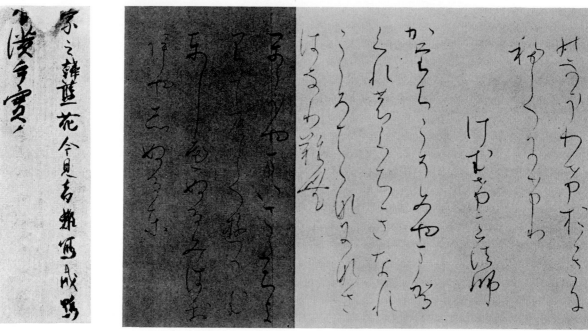

142 (top left). Kara-ai no Uta. Waka *draft on paper scrap; 27.6 × 16.1 cm. About mid-eighth century. Shoso-in, Nara.*

143 (top right). Section of Kokin Waka-shu *(*Manjuin-bon *transcription), attributed to Fujiwara Yukinari. About eleventh century. Colored-paper scroll; height, 14.2 cm. Manju-in, Kyoto.*

144 (bottom left). Masu-jikishi, *attributed to Fujiwara Yukinari. About eleventh century. Mica-decorated paper, 13.8 × 11.8 cm.*

145 (bottom right). Section of letter written on back of "Kokuzo Bosatsu Nenju Shidai." About 966. Height, 33.2 cm. Ishiyama-dera, Shiga Prefecture.

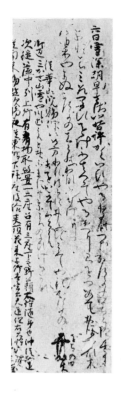

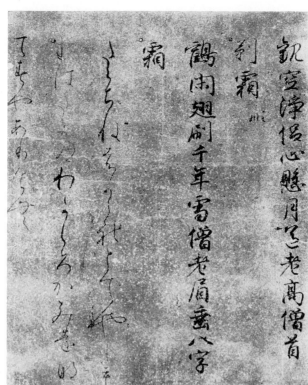

146 (left). Section of Mido Kampaku Michinaga Nikki (diary of the regent Fujiwara Michinaga); 1004. Paper scroll; height, 30 cm. Yomei Bunko Library, Kyoto.

147 (right). Section of Daiji Wakan Roei-shu, attributed to Fujiwara Yukinari. About mid-eleventh century. Colored paper; height, 26.5 cm.

148–49 (opposite page). Sections of Koya-gire (an incomplete transcription of the Kokinshu), attributed to Ki no Tsurayuki. About mid-eleventh century. Paper decorated with mica paste; height, 26.5 cm.

the trees, and this is made an integral part of the composition of the work. The free play of the intellect here gives a very fresh effect. *Kana* works of the Heian period are characterized by this kind of brilliant freedom in composition, quite lacking in Chinese calligraphy. From the Kamakura period onward, with the development of the so-called *ryugi* calligraphy (the calligraphy of the various "schools" of calligraphy), great importance was attached to the format of works. Students of these traditions simply copied the formats handed down in them and any creative qualities were lost. In the early Edo period, however, with the appearance of calligraphers like Hon'ami Koetsu, Konoe Nobutada, and Shokado Shojo, the unique beauty of "scattered writing" returned (Figs. 119, 120, 125).

In Chinese calligraphy there are rules of composition that govern such things as spacing of characters, slant of writing, relative sizes of characters, and so on. In the case of *kana*, harmony of character size, slant, stroke thickness, etc. can be achieved with considerable freedom on account of the gracefulness of the script itself and by means of the subtle lyrical beauty of the *remmen* connected style. This again is something lacking in Chinese calligraphy.

KANA AND PAPER AND INK — Another major characteristic of *kana* calligraphy is the paper used. In China as well, during the T'ang period, beautiful and finely made paper was used for calligraphy. Some

famous Chinese papers are: *hsueh t'ao chien* of Sze-chuan province and the *ch'eng hsin t'ang chih* of the Li family of Southern T'ang. In the Sung dynasty also, colored and figured papers were used. The Japanese *karakami* (literally, "Chinese paper"), was first imported from China, but later was produced in Japan. It is paper decorated with designs printed in mica paste. In his work *K'ao P'an Yu Shih*, Ch'u Lung of Ming gives detailed instructions for making similar paper decorated with gold and silver flower motifs, and we can consider that this is the method for making *karakami* handed down to Ming papermakers.

The variety of paper for writing *kana* included dyed paper, *karakami*, "cloud paper," and some like "flowing ink" (Fig. 155) which required special techniques. *Karakami* is especially beautiful, and comes to mind whenever *kana* are mentioned, since they go so well together. Surprisingly, however, in its homeland *karakami* was not much used, so one feels as if it were a Japanese possession all along.

The exquisite beauty of *karakami* was admired by the court nobility and is truly suited to *kana*. The *Detcho-bon Wakan Roei-shu* in the Imperial Household Collection (Fig. 124), the *Konoe-bon Wakansho* (Fig. 60), the *Hon'ami-gire Kokinshu* (Fig. 59), *Gen'ei* transcription of the *Kokinshu* (Fig. 150), the *Jugo-ban Uta-awase* (Fig. 151), and others, are beautiful examples of *karakami*. Good examples of dyed paper are the *Tsugi-jikishi* (Fig. 57), the *Sekido* manuscript of the *Kokinshu* (Fig. 152), and the *Manju-in Kokinshu* (Fig. 143).

150. Two pages of Kokin Waka-shu *(Gen'ei-bon transcription), attributed to Minamoto Toshiyori; 1120. Karakami paper in sewn binding, 21 × 15.2 cm.*

Elegant paper of indisputably high quality is found in the Nishi Hongan-ji manuscript of the *Sanjuroku-nin Shu* (Figs. 12, 154, 155). This poetry anthology used a variety of papers in addition to *karakami,* such as *michinoku-gami* (wrinkled paper from the present Tohoku region), *atsu-gami* (thick paper), and *koya-gami* (paper reconstituted from used paper). Further variety is added by the methods used to join the pieces of paper together. Sometimes irregular, fuzzy edges (obtained by tearing) are joined; sometimes straight, cut edges. At times collage effects are used, the joins being either edge-to-edge or slightly overlapping. In addition, the paper is sometimes decorated with painted patterns or pictures, sometimes with pieces of gold and silver leaf scattered on it. The skill with which the infinite variety is achieved reaches a dazzling level. The wealth of ideas applied to this sumptuous book indicates that it is the work of someone with quite outstanding artistic talent.

The use of these gorgeous papers was not limited to *kana* calligraphy, but was used for sutra copying also. Examples of these so-called decorated sutras are: *Heike Nokyo* (Fig. 53), *Semmen Hoke-kyo* (Fig. 131).

The graphic beauty of Heian-period paper leads us back to the applied arts of the Nara period, where we can see reflected the naturalistic depiction of T'ang-period arts. The natural scenes—flowers, birds, trees, and landscapes—that appear on the Nara-period musical instruments, decorated boxes, and mirrors in the Shoso-in,

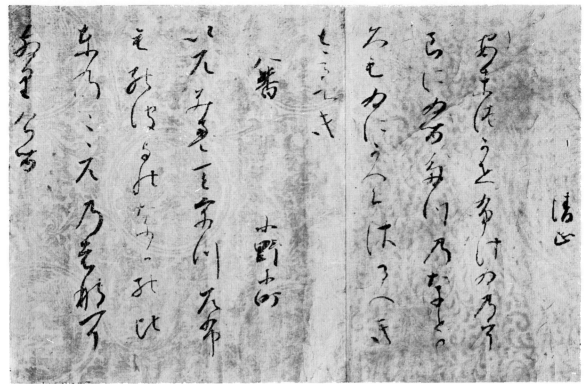

151. *Section of* Jugo-ban Uta-awase, *attributed to Fujiwara Kinto. Late eleventh century.* Karakami-*paper scroll; height, 25 cm.*

as well as those on sutras, have qualities in common with Heian-period paper. And by the Heian period, the essence of these T'ang creations had been so well assimilated that it was beautified and Japanized to an even greater degree, in accordance with the aesthetic standards of the Heian nobility.

The ink used in calligraphy is called *sumi* and is similar to India ink. In China, ink which has the color of black lacquer is highly valued. In the words of the Sung calligrapher Chao Hsi-ku, "Dark ink is a must for *kai, so, ten,* or *rei* writing. When the brush makes a crossover in grass or running style, even where it is the breadth of a hair, the ink must remain dark." On the other hand, in Japanese *kana* modulation of ink tone is prized. The first stroke starts out dark, then as the brush gradually runs out of ink the tone gets lighter and lighter. In this way variation of ink tone is achieved. The distribution of ink tones also requires a careful eye toward the harmony of the total composition, and must be done so as not to create an unbalanced effect. For example, parts of the *Koya-gire Kokinshu* (Figs. 122, 148) are most scrupulous in this regard. In the Heian period, much attention was paid to this technique, which is called *sumi-zuki.*

KAMAKURA AND AFTER

Once we pass the Heian period, *kana* in general do not thrive. In the Kamakura period a strong individualistic *kana* appeared, but this did not last. One reason for this is that the "schools" calligraphy practiced from the Kama-

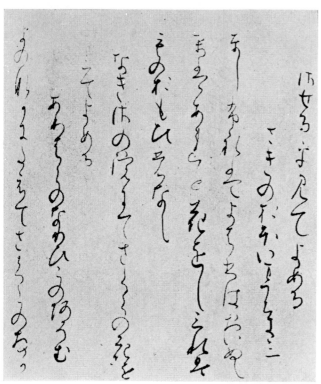

152. *Section of* Kokin Waka-shu *(Sekido-bon transcription), attributed to Fujiwara Yukinari. About eleventh century. Colored paper in sewn binding; height, 20.5 cm.*

153 *(bottom). Section of letter written on back of* Hokuzan-sho; *996–1001. Paper; 30.9×46.7 cm.*

154 *(opposite page). Two pages of* Sanjuroku-nin Shu *(Nishi Honganji-bon transcription; Shigeyuki-shu section). About 1112. "Torn-and-patched" decorated paper in* detcho *glued binding; 20.1 × 31.8 cm. Nishi Hongan-ji, Kyoto.*

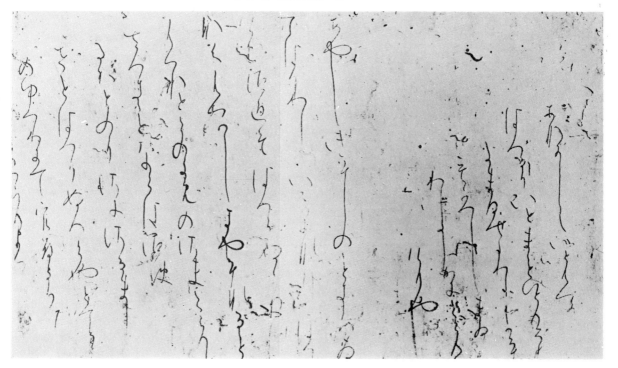

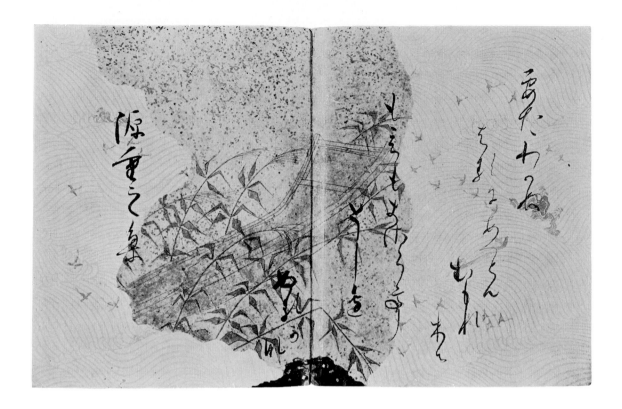

kura period to the Muromachi period was limited to conventional formalism, and the original concept of calligraphy as an art was weakened. (The major schools of the time were the Sesonji-ryu, which was founded in Kyoto by Fujiwara Yukinari and based on the style of Ono no Michikaze; the Shoren'in-ryu, which was founded in Kyoto by Son'en, the son of Emperor Fushimi, who lived from 1265 to 1317; and the Jimyoin-ryu, a branch of the Sesonji-ryu, which started in the Muromachi period.)

Beginning with the three outstanding calligraphers of the early Edo period, the beauty of Heian- and Kamakura-period *kana* was revived, and new, creative works were produced. After this revival, however, practice was once again limited to low-level "schools" calligraphy. From the Meiji period on, along with a sudden surge in research of Heian-period *wayo*, the essential nature of Japanese *kana* was once again recognized. And today, in pace with the spreading popularity of the old calligraphers, a number of fine calligraphers have appeared.

As WE HAVE explained, among the script styles brought to Japan, some were little used, but others took root in Japanese soil and thrived, and from this hardy stock the uniquely Japanese *kana* were produced. Reviewing the whole situation, we can see a basic pattern like this:

Because of Japanese customs, *tensho* and *reisho* were not successful; they were by and large used only for special purposes. Since *kaisho*, being the basic script style, has great practical significance,

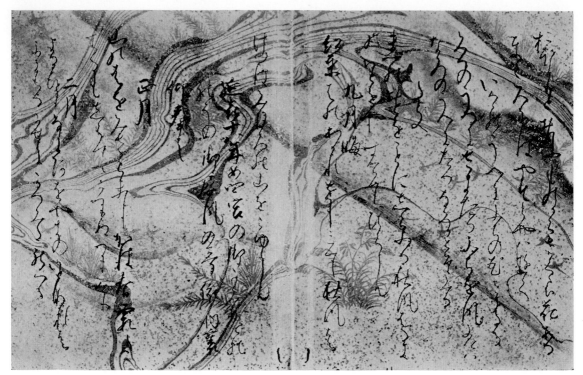

155. *Two pages of* Sanjuroku-nin Shu *(*Nishi Honganji-bon *transcription;* Tsurayuki-shu *section). About 1112.* "Flowing-ink" *decorated paper in* detcho *glued binding; 20.1 × 31.8 cm. Nishi Hongan-ji, Kyoto.*

it always has been and continues to be important. Because running *gyosho* blends well with *kana* and suits the Japanese personality, it is a style that should continue to increase in importance. The *sosho* script is closely connected with *hiragana,* and is the most important style from the point of view of the future development of Japanese calligraphy as an art. The fact that it tends to be emphasized in Japan comes from the essential nature of Japanese calligraphy. In other words, the bond between Japanese calligraphy and *sosho* is so firm that we can say that the art of Japanese calligraphy is the art of *sosho*. However, the script that incorporates the highest essence of Japanese calligraphy is *kana,* and in particular the *hiragana* of the Heian period. Our debt to the women of the Heian period, who conceived and realized the phonetic symbols called *hiragana,* is tremendous. And the artistic development of *kana* is a feat equally worthy of gratitude. It is our duty to preserve the beauty of *hiragana* and to continue the task of developing this beautiful script to even further heights.

The Karayo Tradition

JAPANESE CULTURE as a whole matured under Chinese influence, and in calligraphy this influence is of particular importance. As I mentioned earlier, Japanese calligraphy can be broadly divided into two traditions, the *karayo* tradition that developed under Chinese influence, and the *wayo* tradition with its uniquely Japanese characteristics. From this point, I will consider the growth of these two traditions, the connections between them, and the fundamental nature of Japanese calligraphy. In this chapter I will deal with *karayo,* in the final chapter with *wayo.*

During its long history Japanese calligraphy has received much from the Asian continent. The list that follows shows the continental sources of Japanese calligraphy.

JAPAN	ASIAN CONTINENT
Yamato	Paekche (south-west Korea)
Asuka	Sui and T'ang
Nara	Chin and T'ang
Early Heian	T'ang
Early Kamakura	Sung
Late Kamakura	Yuan (Mongol)
Muromachi and Momoyama	Ming
Edo	*Karayo*-style
Meiji and Taisho	"Ancient school" and "new school"

YAMATO AND ASUKA About A.D. 400, Achiki and Wani, two envoys from Paekche (one of the four ancient Korean kingdoms) arrived in Japan, and with the subsequent adoption of continental literary culture came a system of political organization. At that early date there must already have been some officials proficient in writing characters, but historical examples of such writing are scarce. The only ones extant are the *Eda Kofun Tachi Mei* (Fig. 156), an inscription on a sword excavated from the Funayama burial mound in Kumamoto Prefecture, and the *Suda Hachiman Kyo Mei* (Fig. 158), an inscription on a bronze mirror that is preserved at the Suda Hachiman shrine in Wakayama Prefecture. Judging from the inscriptions, the sword dates from about A.D. 438 and the mirror from 503. In both cases the inscription is written on special utensils, and the script style is a simple *kaisho.*

At that time many Buddhist priests and sculptors, temple builders, painters, and other craftsmen and artists from Paekche arrived in Japan and became naturalized. It is said that these two inscriptions are probably the work of naturalized craftsmen or their descendants. Apart from these two items, the only historical materials giving us information about the calligraphy of that period are documentary references, but actual examples of this writing are virtually nonexistent.

The Asuka period covers the one hundred seven-

156 (left). *Eda Kofun Tachi Mei. Tip half (left) and hilt half (right) of iron sword with silver-inlay inscription. About 438. Length of blade, 90.7 cm. Tokyo National Museum.*

157 (top right) *Section of Kengu-kyo, attributed to Emperor Shomu. About mid-eighth century. Paper scroll; height, 28 cm. Todai-ji, Nara.*

以是之故凡在四輩應自護口
勿妄出言尊優波毱提説此法
時一切大會有得頂陷洹斯陷
舍阿那含阿羅漢者種緣覺善
根者發大乘心遂不退者不可
稱計信受其教歡喜奉行
賢愚經卷第十五

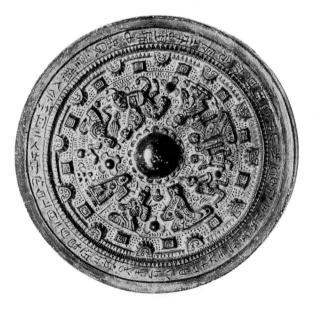

158 (bottom right). Suda Hachiman Kyo. *Mirror with inscription around the edge. About 503. Cast bronze; diameter, 19.8 cm. Suda Hachiman Shrine, Wakayama Prefecture.*

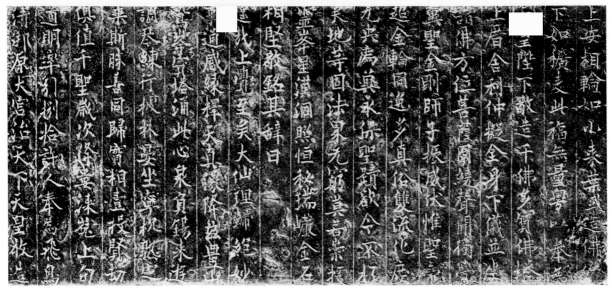

159. Section of Hokke Sesso Doban Mei. *Engraved inscription on gilt bronze; 686. Size of inscription, 14.2 × 42.4 cm. Hasedera, Nara.*

teen year span from 593, when Crown Prince Shotoku became prince regent, to 710, when the capital was moved to Nara. During this period there was frequent contact with the continent. Ono no Imoko was sent as envoy to the Sui court in China in 607–08 and, along with scholars and monks who traveled to the continent, he played an important role in introducing Chinese culture to Japan. In 618 the Sui dynasty fell and the T'ang dynasty arose. Ambassadors to the T'ang court were duly dispatched from the Japanese court and relations with the continent became even closer. In 646, the faction of Prince Naka no Oe and Fujiwara Kamatari initiated the Taika Reform, whereby the T'ang administrative system was put into practice in Japan. Inevitably T'ang culture was widely reflected in the calligraphy of the time.

A few of the most important calligraphic works of this period are: *Ujibashi Dampi,* a monumental column on the bridge at the Hashidera temple in Uji (646; Fig. 83); *Hasedera Hokke Sesso Doban Mei,* a bronze plaque inscription from the Lotus Sutra

at Hasedera (686; Fig. 159); *Kongojo Darani-kyo,* a sutra (686; Fig. 88); *Jomyo Genron,* a discourse on the Vimalakirti Sutra (706); *Obotsu Shijo,* a foreword to the poems of Wang Po (707; Fig. 170).

The examples that survive are inscriptions on stone and metal in the form of monuments, tombstones, and statuary, and "direct" writing in the form of copies of sutras and the *Obotsu Shijo* foreword. In addition there are statue inscriptions and examples of a rather special nature, like a tapestry mandala and graffiti. The characters of the inscriptions on stone and metal have many aspects in common with Chinese Sui-dynasty copies of sutras, but the *Kengo-kyo* (Fig. 80) sutra, which dates from 610 and explains the Hindu-Buddhist pantheon and is kept in the Shoso-in Repository, is closest to this style. The Ujibashi fragment gives very much the impression of the Chinese Hokuhi monument style. As mentioned in an earlier chapter, the Hasedera bronze plaque and the *Kongojo Darani-kyo* are written in a style almost identical to that of Ou-yang T'ung. The *Jomyo Genron,* a

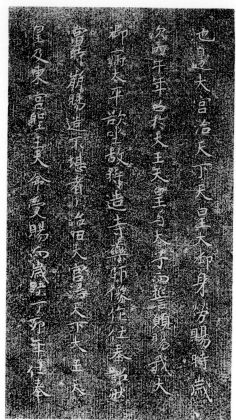

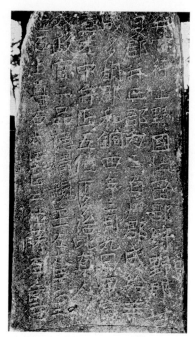

161 (top). Tako-gori no Hi. *Inscription on stone stele; 711. Size, 127 × 61 cm. Yoshii-cho, Gumma Prefecture.*

160 (left). Engraved inscription on gilt-bronze nimbus of statue of Yakushi Buddha. About 607. Size of inscription, 29 × 13.5 cm. Ink rubbing. Horyu-ji, Nara.

sutra manuscript in small characters of a note-taking style, closely resembles sutras of the Chinese Northern Dynasties period. The *Obotsu Shijo* exhibits a traditional Chinese calligraphic style of sharp brushwork. The calligraphy of the Asuka period is virtually all based on that of Sui and T'ang China and many of these works deserve examination.

NARA This period covers the eighty-four years between the removal of the capital to Nara in 710 and the move to the Heian-period capital, Kyoto, in 794. During this time the greatest introduction into Japan of Chinese political, social, literary, and other institutions occurred. It corresponds to the reign of Hsuan Tsuan of T'ang, when T'ang culture flourished at its most spectacular, and, in Japan, the Tempyo era (729–49) of Emperor Shomu. Embassies were frequently dispatched to T'ang China, and Nara, like a blossom's fragrance, reflected T'ang culture. Important examples of metal and stone inscriptions from this period are: *Tako-gori no Hi*, a monument in the Tako district (711; Fig. 161); *Kanaizawa no Hi*, a monument at Kanaizawa (726); *Kofuku-ji Kanzen-in Shomei*, a bell inscription at Kofuku-ji temple (727); and *Oharida no Yasumaro Boshi*, a tomb inscription (729; Fig. 82).

Examples from the Kanto area (around present Tokyo), like the *Tako-gori no Hi* and the *Kanaizawa no Hi* inscriptions, are in a simple style, but the rest are in the same tradition of writing as the

162. *Section of* Enchin Dento Daihoshii Iki. *About 851. Figured-silk scroll; 29.5 × 53.2 cm. Onjo-ji (Mii-dera), Shiga Prefecture.*

metal and stone inscriptions of the Asuka period although with a more exquisite beauty. Some of the finest sutra copies in Japan appear in this period: *Nagaya no Okimi Gangyo* (712 and 728; Fig. 165) and three works from the late Nara period: *Shomu Tenno Gangyo, Komyo Kogo Gogatsu Tsuitachi Gangyo,* and *Kengu-kyo* (Fig. 157). The calligraphy of these *gangyo* (sutras copied out as an act of pious devotion to acquire merit) is truly magnificent. However the most important materials in connection with the calligraphy of this period are the numerous manuscripts preserved in the Shoso-in Repository, works like *Shomu Tenno Shinkan Zasshu* (731; Fig. 87); *Toka Rissei Zassho Yoryaku,* by Empress Komyo (Fig. 16); *Yueh I Lun,* also by Empress Komyo (744; Fig. 86); *Todai-ji Kemmotsu Cho Kokka*

Chimpo Cho, a catalogue of donations to Todai-ji (756; Fig. 85); and *Daisho O Shinseki Cho,* a list of the writings of the two Wangs (758; Fig. 15).

These are works of outstanding quality, all based on the traditional Chinese styles of the Chin and T'ang periods, and masterpieces of the first rank. They represent complete technical mastery, not only in the exquisiteness of their calligraphy but also in their paper, seal impressions, and bindings. Works of this quality were not to be seen in China, so we can see that Chinese calligraphy had been assimilated to a high degree by Japanese during this period. Mentioned in the catalogue of donations to Todai-ji are twenty volumes of rubbings of Wang Hsi-chih's calligraphy, screens inscribed with copies of his calligraphy, and screens inscribed

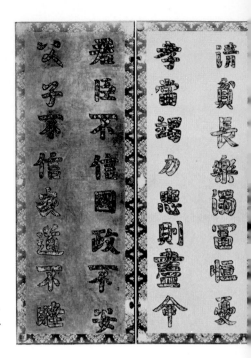

163. Torige Josei Bunsho Byobu. *Sixfold screen. Eighth century. Paper; text in feathered* kaisho. *Each panel, 149 × 56.3 cm. Shoso-in, Nara.*

with the calligraphy of Ou-yang Hsun of T'ang. Unfortunately, these have been lost.

EARLY HEIAN This spans the century or so between the transfer of the capital to Kyoto in 794 and Emperor Daigo's accession to the throne in 897. As before, contact with the continent was carried on by ambassadors to the T'ang court, but the dispatch of these embassies was broken off in 894. The priests Saicho (founder of the Tendai sect at Mount Hiei) and Kukai, together with Tachibana Hayanari, went to T'ang in 804 on the boat of the ambassador Fujiwara Kadonomaro. We know from Saicho's *Shorai Mokuroku* (an inventory of materials brought back from China), Kukai's collection of poetry *Shoryo-shu,* and other biographical records that they brought back to Japan a great deal of material relating to calligraphy.

Among Emperor Saga's works are *Kojokaicho*

(823; Fig. 30) and *Rikyo Hyakuei Dankan* (Fig. 29). The latter faithfully carries on the style of Ou-yang Hsun of T'ang. Extant works by Tachibana Hayanari are: one part of *Sanjujo Sasshi* (c. 805), the *Nan'endo Dotodai Mei* (inscription on a bronze lantern at Nan'endo; 816; Fig. 94) and *Ito Naishinno Gammon* (833; Fig. 28), all outstanding examples of the traditional Chin-T'ang style. Kukai had learned the Chin-T'ang style from childhood and in China he studied not only the traditional calligraphic style of Wang Hsi-chih and his son but also a new T'ang style, which he introduced to Japan. *Roko Shiiki,* written before his trip to China, one part of *Sanjujo Sasshi* (c. 805; Fig. 173), and *Fushinjo* (Figs. 32, 108) exemplify the traditionalist school of the Chin-T'ang style. From the style of Kukai's *Fushinjo* it appears he had carefully studied the kind of *gyosho* style that is engraved on the *Ta T'ang San Tsang Sheng Chiao Hsu Pei,* a pillar erected in 672 and inscribed with Wang Hsi-chih's

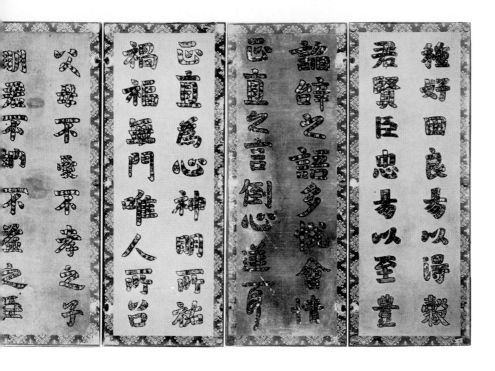

calligraphy. The entry for November 15, 812, in the *Kanjoki* (Fig. 164), the copy of *Shu P'u* in the Imperial Household Collection (Fig. 112), and the calligraphy appended to the representations of Fukukongo, Ichigyo, and Eka in the Portraits of the Seven Shingon Patriarchs are in similar styles and would seem to be based on the T'ang *sosho* style. The *Sheng Hsien T'ai Tzu Pei* by Empress Tse T'ien-wu of T'ang is similar to these, and this type of *sosho* was probably taken from Chinese models. Kukai's copy of *Tsuo Yu Ming* (Fig. 111) is a really beautiful example of this *sosho* technique. Another of Kukai's studies was *zattaisho*, examples of which are *Masuda no Ike no Himei* (Fig. 68) and *Ju Nyoze* (Figs. 67, 69). A more detailed account has already been given in Chapter Four. Kukai's achievements in calligraphy were prodigious, and his writing, which became the nucleus of the Japanese tradition, was an inspiration to later generations.

Saicho, who founded the Tendai sect of Bud-dhism in Japan, went with Kukai to China. Examples of his calligraphy are *Kyukaku Jo* (Fig. 33), *Shorai Mokuroku*, and *Tendai Hokke-shu Nembun Engi*. The *gyosho* style of the letters in the *Kyukaku Jo* is reminiscent of the *Ta T'ang San Tsang Sheng Chiao Hsu* stele (Fig. 18), but it has no equal for dignity and immaculate beauty.

Somewhat later, the priests Ennin, in 838, and Enchin, in 853, crossed over to T'ang China. Many of the extant documents relating to Onjo-ji temple (Mii-dera), with which these two priests were closely connected, such as *Enchin Bosatsu Kaicho* (833), *Ennin Sanju Jo Kaiji* (848–60), *Enchin Dento Daiho-shii Iki* (known as *Nakatsukasa Iki*, with copies on paper and damask; c. 851; Fig. 162), and *Naiguhu ni Atsuru no Chibusho Cho* (850; Fig. 27) are out-standing calligraphic specimens. Enchin took the last two (*Nakatsukasa Iki Chibusho Cho*) with him to China, and reports tell us that they were admired by all the high T'ang officials who saw them, and

164. Section of Kanjoki. *Notebook kept by Kukai; 812–13. Paper scroll; height, 28.5 cm. Jingo-ji, Kyoto.*

apparently copies were made. Since their style is similar to that of the *Ito Naishinno Gammon* (Fig. 28), we can gather that a master of this tradition lived in Japan and transmitted this style. This shows that the finest Chinese tradition had taken deep root in Japan. An example of fine *kaisho* calligraphy from the end of the early Heian period is Fujiwara Toshiyuki's *Jingo-ji Shomei* (bell inscription at Jingo-ji temple; 875; Fig. 95). It is truly fortunate that many of the masterpieces of early Heian calligraphy, which carry the finest T'ang style, are extant today.

LATE HEIAN This covers the period from Emperor Daigo's accession to the throne in 897 until the destruction of the Taira clan in 1185. With the fall of the T'ang dynasty in 907, contact between Japan and China ceased, and Chinese influence after this is not apparent. After the disorder of the Five Dynasties period, the Sung dynasty was established in 960. During this time the *wayo*, or Japanese, style of calligraphy

arose in Japan and a unique calligraphic art was formed. Toward the end of the Heian period there was some appreciation of Sung calligraphy shown by Japanese calligraphers, but before this influence had sufficiently penetrated, the Kamakura period began.

As mentioned above, Japanese calligraphy since Kukai's time has been characterized by a move toward *sosho*, exemplified by the *Hakurakuten Shiku* (Figs. 26, 117), attributed to Emperor Daigo, which shows the influence of the T'ang calligrapher Chang Hsu's *kyoso*, and by the *ayaji-gire* (Figs. 126, 128) and *kinuji-gire* attributed to Ono no Michikaze and Fujiwara Sukemasa, which show the influence of a T'ang *sosho* resembling that of Huai Su. The movement toward the *sosho* originating with Kukai is the foundation of Japanese calligraphy.

KAMAKURA The first part of this period begins with the destruction of the Taira clan in 1185 and ends with the fall of the Southern Sung dynasty in 1279. During the Kamakura

165. Nagaya no Okimi Gangyo;
712. Paper scroll; height, 23 cm. Nezu
Art Museum, Tokyo.

period there was a resurgence of traffic between Japan and the continent. Due to the military government instituted at the onset of this period by the Minamoto family, we see hereafter a change from the refined, gentle beauty of the imperial-court culture to the straightforward strength of a military establishment.

The calligraphy of Sung China was brought back principally by the famous monks who had studied in China. The monk Myoan Eisai, who founded the Kennin-ji temple in Kyoto, crossed over to China twice in the years 1168 and 1187 and became the successor in the line of patriarchs for the Oryo branch of the Rinzai Zen sect, bringing these teachings to Japan. His *Urabon Ippon-gyo Engi* is written in *kaisho* on colored paper and in the style of Huang Shan-ku.

The Zen monk Shunjo of the Ritsu sect went to Sung China in 1199 and studied for thirteen years. Upon his return to Japan he founded the Sennyu-ji in Kyoto. The seventy-six scrolls of copybooks and inscriptions that he brought back exerted a great

influence on the development of calligraphy then. We have the *Kan'enso* (1219; Fig. 127), done at the time Sennyu-ji was constructed. It is a splendid piece done in *gyosho* of the Huang Shan-ku style on paper decorated with a colored design. After this, Kigen Dogen went to Sung in 1223. He founded the Eihei-ji, near Fukui, and in calligraphy his *Fukan Zazen-gi* (Fig. 166) is famous. This work is written in *kaisho* on Sung wax-decorated paper, and is in a pure style that resembles Huang Shan-ku's brushwork. At the time these monks went to China, in the first half of the Southern Sung period, the styles of Su Tung-p'o and Huang Shan-ku were very popular, and this influence reached into Japan. Following this, in 1235, Enni Ben'en went to Sung China and was pronounced a Zen master by his teacher Wu-chun Shih-fan of Ching Shan. He returned and established Tofuku-ji temple. It is said that he studied Chang Chi-chih, who was close to the Zen monks, so that today his works seem to be written in a Zen style, diverging from the established techniques. After Enni Ben'en's visit to Sung

普勧坐禅儀

入宋傳法沙門道元撰

原夫道本圓通爭假修證

宗乗自在何貴功夫況宇

全體逈出塵埃孰信拂拭之

手段大都不離當處豈用

修行之脚頭然而毫釐有

差天地懸隔違順纔起紛然

失心須知歷劫輪廻還因擬議

之一念塵世迷道兇由商量

166. Section of Fukan Zazen-gi, *by Kigen Dogen; 1233. Scroll of wax-decorated paper; 28.7 × 319 cm. Eihei-ji, Fukui Prefecture.*

a succession of famous Sung monks came to Japan and were naturalized. In 1246 Rankei Doryu (in Chinese, Lan-ch'i Tao-lung) was invited to come by the regent Hojo Tokiyori. He came, was naturalized, and founded Kencho-ji, a Zen temple in Kamakura. He was proficient in the style of Chang Chi-chih and many of his works (Fig. 167) are extant today.

During late Kamakura the Southern Sung dynasty was demolished and the Mongol Yuan dynasty arose in 1279, lasting until 1368. There is an anecdote to the effect that Mugaku Sogen (Wu-hsueh Tsu-yuan in Chinese), in the midst of the Mongol versus Sung war, dispatched threatening Mongol warriors with the verse, "a highly valued three-foot Mongol sword, in a flash of lightning, cuts the spring breeze." He followed Rankei Doryu, the founder of Kencho-ji, to Japan in 1279 at the request of Hojo Tokimune, was naturalized, and established the Zen temple Engaku-ji in Kamakura. He also wrote a style filled with Zen feeling directly expressing his personality. Issan Ichinei (I-shan I-ning in Chinese), who was ambassador between Yuan China and Japan after the attempted Mongol invasions of Japan, came to Japan in 1299, was naturalized, and converted Hojo Sadatoki to Zen. He resided at both Kencho-ji and Engaku-ji temples but later, at the request of Emperor Go-Uda, moved to the Nanzen-ji in Kyoto. He did good *sosho* and was exceptional among Zen monks for his flowing style of calligraphy (Fig. 138).

With the rise of the Rinzai sect of Zen Buddhism, Japanese Zen monks who could do good calligraphy appeared. The three especially prominent calligraphers of the time were: Muso Soseki, the founder of Kyoto's Tenryu-ji; the scholar-monk from Tofuku-ji, Kokan Shiren (Fig. 172); and the founder of Daitoku-ji, Shuho Myocho (also known as Daito Kokushi; Fig. 137). Muso excelled in a refined style of *sosho* resembling that of Issan Ichinei. Kokan took only Huang Shan-ku as a model,

167. Section of Fujumon, *by Rankei Doryu (Lan-ch'i Tao-lung). Thirteenth century. Paper; 32.4 × 95.1 cm. Tokiwayama Bunko Library, Kanagawa Prefecture.*

while Daito, who may be the best of this period, wrote a broad and powerful script. These are representative examples of Zen calligraphy, which shuns technicality.

The influence of the calligraphic styles of Sung China was eventually felt even by the emperor and the nobles, and Sung styles are evidenced in the writing of *kaishi* poem sheets, imperial edicts, etc. The calligraphy of emperors Hanazono (Fig. 136) and Go-Daigo, who were converted to Zen and took up the study of Sung philosophy, clearly show the Sung style of Zen calligraphers.

There was a succession of high Zen monks who entered Yuan China around the beginning of the fourteenth century. Some of those who traveled to Yuan were Sesson Yubai, Jakushitsu Genko, Getsurin Doko, Chugan Engetsu, and Tesshu Tokusai, all of whom were good calligraphers. The typical style practiced in the Yuan dynasty was that of the great calligrapher Chao Tzu-ang. The Rinzai Zen monks in China were also skilled in this style, men

like Ku-lin Ch'ing-mao, Yueh-chiang Cheng-yin, Liao-an Ch'ing-yu, Ch'u-shih Fan-Ch'i, who were also famous for first-rate calligraphy. The Japanese Zen monks who had dealings with these Chinese monks also picked up this style of writing. The calligraphy of Zen monks from the end of the Kamakura period through the Northern and Southern Courts period does not simply rely on Zen inspiration; some monks were also technically proficient. Their skill is due to the influence of the calligraphic style of Chao Tzu-ang.

MUROMACHI AND MOMOYAMA

This is the age between the unification of the Northern and Southern Courts in 1392 and the establishing of the Edo shogunate in 1603. Even after the destruction of the Yuan dynasty in 1368 and the establishment of the Ming, Japanese Zen monks continued to cross over to the continent. In 1368 Zekkai Chushin (Fig. 84) entered Ming China and studied

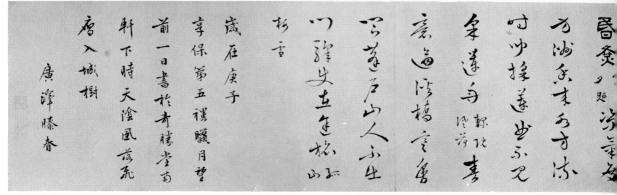

168. Calligraphy by Hosoi Kotaku; 1720. Section of paper scroll; 28.8 × 313.8 cm. Tokyo National Museum.

under Chi-t'an Tsung-le. His calligraphy teacher was Ch'ing-yuan Huai-wei. These two men were in the patriarchal lineage of Hsiao-yin Ta-hsin and were also famous calligraphers. In 1396 a student of Zekkai Chushin's, Gakuin Ekatsu, and in 1401 Chuho Chusei, a successor of Donchu Doho, went to Ming China. The latter's proficiency in *kaisho* has been mentioned before. There were at that time several Japanese Zen monks who were known in China for their calligraphy. In the *Shu Shih Hui Yao* by T'ao Tsung-i of early Ming, the names of two Japanese Zen monks, Tonan Eiketsu and Gonchu Chuson are listed, and Yu Shih-nan of T'ang is given as their model. Through Zen monks this style reached Japan.

Much later, in 1511, Ryoan Keigo of Tofuku-ji crossed to Ming China, and while studying there met the famous politician Wang Yang-ming, who was also a renowned calligrapher. When Ryoan returned to Japan he was graced with a going-away present from Wang. After this, Sakugen Shuryo of Tenryu-ji went to Ming China twice, in 1539 and 1548, and while studying there he also met the famous calligrapher Feng Fang. In the Myochi-in, a subtemple of Tenryu-ji, there is much material relating to him. The scholar-monks Ekishi Shushin

and Osen Keisan, although they did not travel to Ming, were excellent calligraphers.

The calligraphy of the Zen monks during the Muromachi period does not have the same subtle flavor deriving from the outstanding personalities of those of the Kamakura and Northern-Southern Courts periods, and the only prominent practitioner of this sharp, eccentric style of writing was Ikkyu Sojun. It is he who wrote the line "Shoso Bodaidaruma Daishi" (the first patriarch and great Zen teacher Bodhidharma) for Murata Juko, the originator of the tea ceremony. From this arose the practice of appreciating Zen calligraphy along with the tea ceremony. It is because of this that many works by these masters were passed down.

EDO PERIOD This long period covers the 260-odd years from the founding of the Edo shogunate by Tokugawa Ieyasu in 1603 until the full restoration of political power to the emperor by the shogun Yoshinobu in 1868. I shall consider it under four subperiods.

The first period is from the first shogun Ieyasu to the third shogun Iemitsu (d. 1651), a span of fifty years or so, and is the period of the establish-

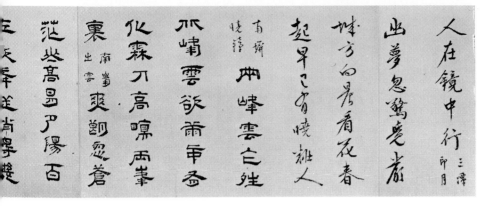

ment of the shogunate. Christianity was proscribed and in 1635 the "closed country" policy was initiated, putting a stop to intercourse with the continent. Calligraphic studies were reduced to the study of *karayo* Chinese-style works transmitted via Korea. Even the Confucian scholars produced virtually no calligraphy worthy of attention. The publication of copybooks, too, almost petered out, although a positive, black-on-white printed edition of Su Tung-p'o and Huang Shan-ku's calligraphy came out in Kyoto about 1645.

The second period is from 1652 until 1736—from the fourth shogun, Ietsuna, to the eighth, Yoshimune. In this period there are three types of *karayo* style. One is that of the Obaku sect of Zen Buddhism, which was brought to Japan in 1654 by the naturalized monk Ingen. In 1661 he was given permission by the shogun to establish the Obaku-san Mampuku-ji temple in the Uji area near Kyoto. Ingen's spiritual heirs Mokuan, Sokuhi, and Kosen were of Chinese extraction and were skilled in calligraphy. They created a calligraphic style characteristic of this sect. The calligraphy of the founder Ingen (Fig. 169) has a gentle, massive quality that was much liked, as was his personality. Dokuryu, who became a monk under Ingen al-

though he came to Japan one year earlier, was already a famous calligrapher in China. He had mastered the history of characters and the theory of brushwork, and had a masterful *sosho* style different from that of the other Zen monks at Mampuku-ji. A pupil of Dokuryu's named Ko Gentai and another man living in Nagasaki at that time, Hayashi Doei, were together called the Two Graces. These men were influential in the spread of the *karayo* style.

As the second stream of *karayo,* there were the pupils of Fujiki Atsunao, the founder of the Daishi school; Toriyama Sompo, Sasaki Shizuma, Kitamuki Unchiku, and Terai Yosetsu. These made a study of the "*eiji happo*" ("the eight principles embodied in the character *ei*") and the "seventy-two types of *hissei*" (literally, "brush energy" or "brush momentum"), as expounded in the Ming copybook *Nei Ke Mi Ch'uan Tzu Fu,* and made these principles the basis of their technique. In 1664, the book was reprinted from new blocks in Kyoto and became widely used, serving as a popular primer of the *karayo* style. It is worthy of note that many of the calligraphers in this faction also wrote in the *wayo* Japanese style.

The third group is represented by Kitajima

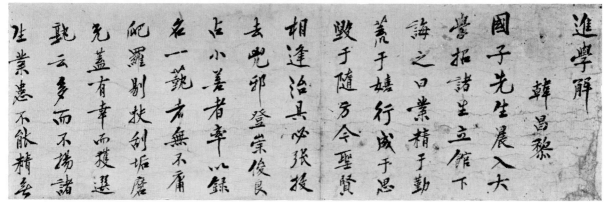

172. Calligraphy by Kokan Shiren. Early fourteenth century. Section of paper scroll; height, 30 cm. Tofuku-ji, Kyoto.

Setsuzan (Fig. 174) and Hosoi Kotaku (Fig. 168) of the same tradition. Kitajima studied the technique of the Ming calligrapher Wen Cheng-ming under Yu Li-te, a Chinese in Nagasaki, and he passed this on to Hosoi. Hosoi then wrote the *Hatto Shinsen* (1 vol.; 1719) which clarified the techniques he had received. In 1724 he published the *Shibijiyo* (1 vol.) which explained the eight principles and eight defects illustrated in the character *ei*, and one hundred and sixty brush techniques. In addition he edited a five-volume work, the *Kanga Hyakudan*, in 1735, dealing with matters relating to calligraphy and in general making contributions to the advance of the *karayo* style. He turned out many good calligraphers among his disciples, beginning with his son, Kyuko, and including Hirabayashi Junshin, Seki Shikyo, and Mitsui Shinna. In Edo (present-day Tokyo) the popularity of the *karayo* style spread widely among the literati.

The third period is from c. 1736 to the early 1800s. In the time of the eighth shogun, Yoshimune, attention was focused on restoring the national economy and fostering industrial growth. In general, the Gembun era (1736–41) is taken as the border after which the strict isolationist policy was finally relaxed, and, with Nagasaki as the

entryway, Chinese cultural imports picked up quickly. Chinese calligraphers, both naturalized and visitors to Nagasaki, spurred Japanese calligraphy into activity.

The most outstanding phenomenon of this period is the importing and reprinting of copybooks and pillar inscriptions. This tendency, in general, increased during the third quarter of the eighteenth century. The catalogues of the times reveal the names of many famous calligraphers, among them Wang Hsi-chih of Chin; Chih Yung of Sui; Hsuan Tsung, Ou Yang-hsun, Li Yung, Yen Chen-ch'ing, Chang Hsu, and Huai Su of T'ang; Mi Fu and Chang Chi-chih of Sung; Chao Tzu-ang of Yuan; Chiang Li-kang, Chu Yun-ming, Wen Cheng-ming, Wang Ch'ung, T'ang Yin, Tung Ch'i-ch'ang, and Chang Jui-t'u of Ming; and others. Among these, however, Chao Tzu-ang, Chu Yun-ming, Wen Cheng-ming, and Tung Ch'i-ch'ang are by far the most abundantly represented, and we know from this what kinds of calligraphy were introduced at that time and how flourishing *karayo* calligraphy was.

There were two tendencies in the choice of copybooks. One group was the traditionalists, who preferred the works of Wang Hsi-chih, Chao Tzu-

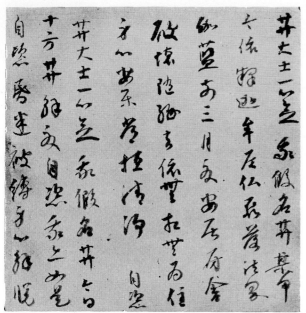

173. Section of Sanjujo Sasshi. *Transcriptions of miscellaneous Buddhist texts compiled by Kukai; calligraphy by various hands. Calligraphy of this section by Kukai. About 805. Paper; detcho glued binding; 14 × 14 cm. Ninna-ji, Kyoto.*

174. *T'ang poem. Calligraphy by Kitajima Setsuzan. Four ▷ panels of sixfold screen. Late seventeenth century. Paper.*

ang, and Wen Cheng-ming. The other group, the reformists, preferred Chang Hsu, Huai Su, Mi Fu, Tung Ch'i-ch'ang, Chang Jui-t'u, etc. Matsushita Useki, who studied with Sasaki Bunzan of Edo, and was a friend of Hosoi Kotaku, admired Wang Hsi-chih. Kan Tenju of Ise, a student of Matsushita Useki's, himself carved the blocks for a collection of stele inscriptions and was the most influential man in the spread of *karayo*-style calligraphy. Sawada Toko studied with Isai, the son of Ko Gentai, and was well versed in calligraphic studies. He had a discerning judgment with regard to inscriptions and copybooks, was an admirer of Wang Hsi-chih, and advocated a return to the Wei and Chin periods for calligraphic models (Fig. 97). Among the "reformist" group, Cho Tosai of Naniwa (the modern Osaka) admired the *sosho*

work of Chu Yun-ming, who had studied Huai Su. Among his students are Totoki Baigai, Rai Shunsui, and others. Thus the popularity of the *karayo* style among writers and scholars presented the appearance of all kinds of flowers in bloom.

The fourth period is from c. 1804 until the full restoration of the throne by the shogun Yoshinobu in 1868. The *karayo* style that came in through the entryway of Nagasaki flourished all the more in this period. Inscription materials became plentiful and there was increasing awareness and appreciation. Ichikawa Beian (Fig. 175) of Edo had a profound knowledge of calligraphy and was the author of many books including *Beika Shoketsu* in 1801; *Shin Sanka Shoron* in 1824; *Ryakukaho* in 1827; *Beian Bokudan* in 1812 (second vol. in 1827); *Bokujo Hikkei* in 1838; and as well an edition of the

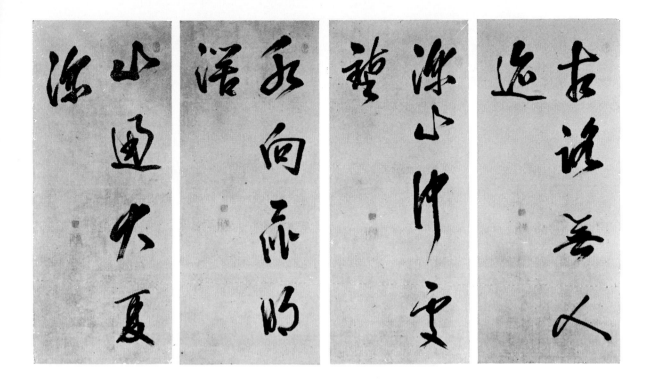

"Thousand Character Essay" and copybooks in each style, treating calligraphy, painting, antiques, and writing equipment. While he prized the work of Mi Fu of Sung, his basic orientation was toward the calligraphy of the Ming and Ch'ing periods. He was the last of the great modernists in the lineage of the *karayo* style in Edo. Nukina Kaioku, who lived in Kyoto, was also an admirer of Chin and T'ang inscriptions, especially of the famous T'ang works brought to Japan in early Heian times. In his last years he perfected a dignified *karayo* style. We can say that in contrast to Beian's modernist *karayo* faction, Nukina was the very crystallization of the traditionalist *karayo* stream (Figs. 22, 176). One other Edo man who, in contrast to the modernists, studied the Chin-T'ang works was Maki Ryoko (Fig. 99). He had a thorough knowledge of characters, and published the *Juttai Genryu,* a penetrating study of the origins of the script styles. His calligraphic style was widely practiced.

Aside from the *karayo* styles of the Edo period already discussed, one other type, which might perhaps be called "deviant," should be mentioned. This is the calligraphy of literati and Buddhist priests, who, transcending the fashions of the ordinary world, expressed their personalities in the art of calligraphy. Some of these were Jakugon (Fig. 93), Jiun (Fig. 92), and Ryokan (Fig. 90). Ike no Taiga (Fig. 91) may be included here too. Although this too is classified as Chinese-style calligraphy, it is essentially different from the copybook-based *karayo* of the Confucianists, with their lifelong worshiping of Chinese civilization.

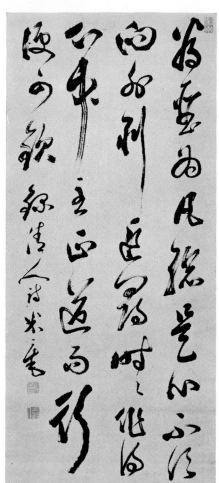

175. Ch'ing-period poem, by Ichikawa Beian. About mid-nineteenth century. Paper, 132 × 60 cm.

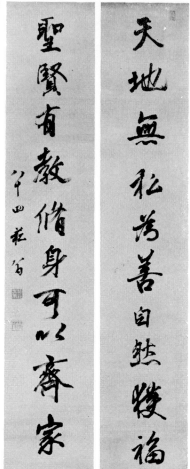

176. Calligraphy by Nukina Kaioku; 1861. Satin; each column, 135 × 25 cm.

Today it is the work of these "deviant" calligraphers that is judged to have the greatest artistic value.

MEIJI AND TAISHO

At the beginning of Meiji (1868) the traditions of the famous calligraphers of the late Edo period, Ichikawa Beian, Nukina Kaioku, Maki Ryoko, Kojima Seisai, and others, were propagated, and the Edo-period *karayo* style became even more popular. Beian's style was passed to his son Ban'an and to his disciple Tanko Ishii. Kaioku's was transmitted to Senshin Ochi, Chikutan Ue, Takusai Kobayashi, Chiman Wada, and others. Maki Ryoko's was passed to Shugan Hagiwara and Ryotan Maki, while Seisai produced Deishu Takahashi and Soken Nomura (Fig. 103). The styles of the end of the Edo period still had great influence at the beginning of the Meiji period. During this period there were also people like Cho Sanshu, who developed a distinct style based on the study of Yen Chen-ch'ing of T'ang, while people like

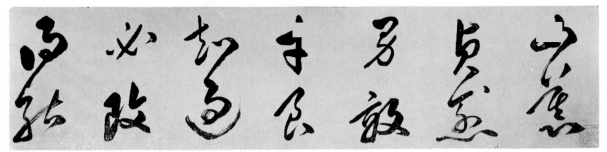

177. *Section of* Sosho Senjimon *(Thousand Character Essay in Sosho), by Matsushita Useki. Eighteenth century. Paper scroll; height, 29 cm.*

Kindo Kanai, Taiiki Naruse, and Banka Yoshida preserved the traditional *karayo* style of the Edo period. The *Shoho Shoron* (1885) by Kosai Ishikawa indicates well the knowledge of calligraphy and attitudes held by the conservative group.

In 1880 the Ch'ing scholar Yang Shou-ching came to Japan bringing with him many rubbings of inscriptions from the Han, Wei, Six Dynasties, Sui, and T'ang periods. He had a deep knowledge of copybooks of metal and stone inscriptions and had authored the famous *Wang T'ang Chin Shih Wen Tzu* and the *K'ai Fa Su Yuan.* His *P'ing Pei Chi, P'ing T'ieh Chi,* and *Hsueh Shu Erh Yen* greatly benefited the Japanese calligraphic world. The two Japanese who best followed his example were Meikaku Kusakabe (Fig. 102) and Ichiroku Iwaya (Fig. 182). These two at first studied the style of Maki Ryoko, but they became ardent admirers of the monument inscriptions brought over by Yang Shou-ching, especially the Hokuhi northern monuments, not available in Japan until then.

The Hokuhi style in Japan started from this. The Hokuhi, or northern monuments, are inscribed stone pillars of about the fifth and sixth centuries from the northern Wei area. From about the middle of the Ch'ing period these inscriptions enjoyed great popularity among Chinese calligraphers. At the time these monuments were very rare. Meikaku Kusakabe, however, was no mere imitator of Hokuhi inscriptions. He had studied the Chin and T'ang style before taking up Hokuhi and although he never departed from tradition (because of his deep admiration for his teacher Nukina Kaioku), he left many fine monument inscriptions in *reisho* and *kaisho.* His pupils were numerous and he had a great hand in laying the foundations of present-day calligraphy.

During the Meiji era, students continued to travel to Ch'ing China to study the new calligraphic styles, and these late-Ch'ing styles were also brought to Japan. Gochiku Nakabayashi (Fig. 34) admired P'an Ts'un, the teacher of Yang Shou-ching, and went to Ch'ing. He studied Hokuhi models and developed his own distinctive style. Shinsen Kitakata also went to Ch'ing and studied the calligraphy of the late-Ch'ing-dynasty Hokuhi school. Many calligraphers of the late Ch'ing period in this school were good at seal carving, in addition to writing good *tensho* and *reisho*, and quite a number of Japanese seal carvers went to Ch'ing. Kitakata, among others, was a fine seal carver. The famous calligraphers who specialized in seal carving were Taiu Maruyama, Tetsujo Kuwana, Zoroku Hamamura, Senro Kawai, and others. These men were all friends of such late-Ch'ing Hokuhi calligraphers as Hsu San-keng, Chao Chih-ch'ien, and Wu Ch'ang-shih and were greatly influenced by them.

CHAPTER ELEVEN

The Wayo Style

DURING THE YAMATO period (300–710) Japan depended upon the culture of the southwest Korean kingdom of Paekche (in Japanese, Kudara), so it is doubtful whether Japan had a calligraphy of its own. In the Asuka period as well, Japan adopted the calligraphy of Sui- and T'ang-dynasty China unchanged, so in this early period we cannot as yet detect a Japanese style. In the Nara period the first materials in *kana,* the two *Man'yo-gana Monjo* (Fig. 129) appear. However, the style of these documents is also derived from the unconnected *sosho* style of Wang Hsi-chih, so that while it has a Japanese feeling, it does not really fully exhibit the characteristics of Japanese calligraphy. The early Heian was the period when T'ang-style calligraphy thrived most in Japan, and even the *kana* document *Sanuki no Kokushige Aritoshi Moshibumi* (867; Fig. 133) is simply *man'yo-gana* in *sosho* form, i.e., Chinese *sosho* characters used phonetically.

LATE HEIAN During this time, around the reign of emperors Uda and Daigo, *hiragana* arose and Japanese *wayo* calligraphy was established. Ono no Michikaze and Fujiwara Sukemasa are of this period, and were followed by Fujiwara Yukinari. A uniquely Japanese style of calligraphy began to unfold on a grand scale. In the works of Michikaze, *Byobu Dodai* (Fig. 107), *Chisho Daishi Shigo Chokusho* (Fig. 123), and *Gyokusenjo* (Fig. 179); Sukemasa's *Shikaishi* (Fig. 106) and

Rirakujo (Fig. 183); and Yukinari's *Hakurakuten Shikan* (Fig. 104) and *Shosoku* (Fig. 180), the *wayo* characters have taken on a truly Japanese appearance, being written in an elegant, graceful manner. With the development of *hiragana,* a uniquely Japanese quality is even more apparent, and the most beautiful art in Japanese calligraphy was created. Many of these works have been passed down to the present day. Their beauty is the very typification of Japanese calligraphy.

Kana works of this period are still extant in large numbers because connoisseurs took good care of them. The reason for this was twofold—the gorgeous beauty of the materials used, and the fact that fragments of poetic anthologies, being antique calligraphies, were used as models for practice or mounted and prized as kakemono by tea-men and other connoisseurs. Naturally, changes in style can be seen, making possible a tripartite classification into early, middle, and late periods. First, the *Jikashu-gire,* said to be the work of Ki no Tsurayuki (Fig. 181), is thought to be from a relatively early period. *So kana* (i.e., cursive *man'yo-gana*) were used even after the development of *hiragana,* as can be seen in the *Ganouta-gire* (Fig. 55), supposedly by Fujiwara Sukemasa, and the *Akihagi-jo* (Fig. 54) attributed to Ono no Michikaze. These two are probably comparatively old examples of *so kana.* By gradual modification, *so kana* developed into *hiragana,* but even when the use of *hiragana* was at its height, the *so kana* from which they originated

178. Section of scroll of waka *poetry. Calligraphy by Konoe Iehiro. About early eighteenth century.* Karakami *paper; height, 26.5 cm.*

were used occasionally as a special calligraphic style.

The most representative *kana* work of this golden age is the *Koya-gire* (Figs. 122, 148, 149). In this we can see three styles of writing, each with its own characteristics: first, a very elegant, relaxed style; second, a traditionally strong yet refined style; third, a brilliant, tasteful style. There are extant writings by the same hands or at least in the same traditions. The *Daiji Wakan Roei-shu* (Fig. 147) is an example in the first style; the *Katsura-bon* version of the *Man'yo-shu* (Fig. 58) and *Kumogami-bon* version of *Wakan Roei-shu* (Fig. 184) are in the second style; the *Detcho-bon* version of *Wakan Roei-shu* (Fig. 124), *Konoe-bon Wakan Roei-shu* (Fig. 60), and *Horai-gire* (Fig. 186) are examples of the third. From this we know that three calligraphic styles corresponding to the three styles of the

Koya-gire were widely practiced. Aside from these, the *Sunshoan Shikishi* (Fig. 56), the *Hon'ami-gire* (Fig. 59), the *Sekido-bon* version of *Kokin Waka-shu* (Fig. 152), the *Manjuin-bon* version of *Kokin Waka-shu* (Fig. 143), and the *Masu-jikishi* (Fig. 144) vied with each other in beauty.

In the latter part of the Heian period calli-graphic styles in general took on a rough, tough-spirited quality, as can be seen in the *Ranshi-bon* version of *Man'yo-shu* (Fig. 185), *Jugo-ban Uta-awase* (Fig. 151), *O-jikishi* (Fig. 187), and the *Sakai-jikishi*. Furthermore, as we can see in the *Gen'ei-bon* version of *Kokin Waka-shu* (Fig. 150) and the *Nishi-Honganji-bon* version of *Sanjuroku-nin Shu* (Figs. 12, 154, 155), the paper is exquisite, and a tremendous variety of formats were used. While the style well represents the quality of the

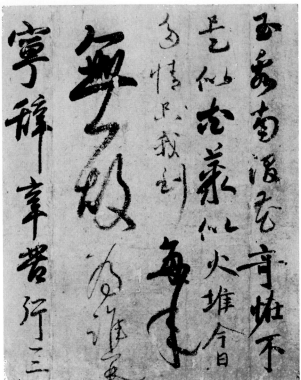

179. Section of Gyokusenjo (Hakushi Monju Dankan: Fragments of Anthology of the Works of Po Chu-i), by Ono no Michikaze. Tenth century. Paper scroll; 27.6 × 188 cm. Imperial Household Collection.

180 (opposite page, left). Section of letter written by Fujiwara ▷ Yukinari; 1020. Paper; 32 × 46 cm.

181 (opposite page, right). Section of Jikashu-gire, attributed ▷ to Ki no Tsurayuki. C. late tenth century. Paper; 26.5 × 33.6cm.

golden age of *hiragana*, many new ideas are also represented. As in the *Genji Monogatari Emaki* (Fig. 121), explanations inserted between pictures in picture-scrolls took on an even greater beauty, and this ripe, radiant beauty flourished until the very end of the period.

As might be expected, toward the later part of the Heian period the authority of the nobility weakened and the military began to grasp power. With restlessness among the farming population there was a gradual and widespread change in the mood of the times. An individualistic, free, strong beauty came to be looked for, rather than the ideal beauty prevalent until then, and it gradually took on a "no frills" kind of quality. Thus we enter the Kamakura period—the age of the warriors.

KAMAKURA AND MUROMACHI

In the Kamakura period the culture of the nobility was gradually giving way to the culture of the military. Calligraphy too was fundamentally different from that of the Heian period, as can be seen in the stern, thorny writing of Fujiwara Toshinari (Fig. 140) and the strident rhythms of Fujiwara Sadaie's willful calligraphy (Fig. 139). These works are characterized by self-expression rather than a concern with technical skill. The style, however, did not last long.

On the other hand, the calligraphy of the Heian period was preserved by the nobility within the formally established traditions, or "schools" (*ryugi*). The Seson-ji school, founded by Fujiwara Yukinari, continued the tradition of Fujiwara

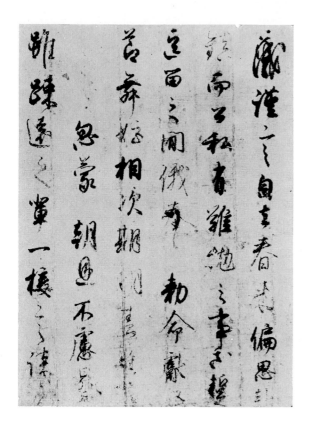

Koreyuki of the late Heian period even at this late date, and the hereditary succession passed down through Koretsune, Koreyoshi, Tsunetomo, Tsunetada, Yukifusa, and Yukitada. Each strove to preserve the tradition, with the result that merely teachings about conventional formats and brush techniques were passed down. The creative will was lost and calligraphy began to become fixed. It was turning into the so-called *ryugi shodo* or "schools" calligraphy.

The Seson-ji school was perhaps the mainstream of this movement, but Fujiwara Tadamichi's Hossho-ji school and Fujiwara Yoshitsune's Go-kyogoku school were also popular at the time, as were those of Fujiwara Noriie and Emperor Fushimi. In general these traditions stuck to the formalism of *ryugi* calligraphy and tended toward a utilitarian calligraphy that preserved the tradition. Socio-political conditions and the mode of life of the nobility were causative factors of this phenomenon; living in an atmosphere of war and downfall, the formalism of *ryugi* calligraphy, clinging as it did to tradition, must have been an island of peace for the courtiers. The situation was the same in the Northern and Southern Courts period and the Muromachi period.

From late Kamakura into the Northern-Southern Courts period, Son'en Shinno (Fig. 135) carried on the tradition of the Seson-ji school, strongly opposing the then-popular Sung style, and emphasizing the study of traditional Japanese calligraphy. His tradition is called the Son'en school or

183. Section of Rirakujo. Letter written by Fujiwara Sukemasa; 991. Paper; height, 30.5 cm.

182. Calligraphy by Ichiroku Iwaya. About early twentieth century. Paper; 171.5 × 29 cm. Shodan-in, Tokyo.

Shoren-in school, and later became the O-ie school of the Edo period, when it found widespread use as an official style. The Seson-ji school lasted into the Muromachi period, but the lineage was broken when the seventeenth successor, Yukisue, had no heir, and Jimyo-in Motoharu became the successor. From this time the tradition was known as the Jimyo-in school. Thereafter the Son'en and Jimyo-in schools were equally widely practiced. "Schools" calligraphy played an important role in the Muromachi period, but in general their work was of truly poor quality.

EDO PERIOD At the beginning of this period three great calligraphers appeared—Hon'ami Koetsu (Fig. 125), Konoe Nobutada (Fig. 120), and Shokado Shojo (Fig. 119). They swept away the conventionalism of the Muromachi and produced high-quality works of a new creative art.

Koetsu's original occupation was as an appraiser of swords, but, having outstanding artistic genius, he showed unequaled creativity not only in calligraphy but also painting, lacquerwork, and pottery. In the field of calligraphy, he took up

the decorative ideas that the Heian nobles had developed, and took these further with his own ideas. He had paper made to his own order, and on this painted a soft, tasteful ground-decoration, in silver and gold pigments reminiscent of the *maki-e* technique, in the style of Sotatsu or his school. Over this background his characters would be distributed looking like birds or butterflies frolicking amid the grass and flowers. With unconstrained brushwork he wrote skillful combinations of *kanji* and *kana* in a variety of stroke thicknesses and ink tones, producing an unsurpassed beauty. In his work are manifested the gentle sentiments characteristic of Japanese art and an indescribable joy in nature with its fragrant flowers. He had an originality never seen before. Koetsu originally studied the calligraphy of the Shoren-in school, but was not shackled to this tradition. He was attracted also by the sharp, energetic brushwork of the Kamakura-period priests influenced by Chang Chi-chih and perfected a personal calligraphy of his own that grasped the very essence of the art.

Konoe Nobutada at first came from the Son'en school, but his was an unrestrained, free-wheeling, rough kind of writing, probably the expression of his personality. He produced a style of calligraphy that seems to have resulted from the addition of the unfettered spirit of the Zen monks to *kana*, which usually tend to lapse into a feeble delicacy. The dignity of his style would be exceptional in any age.

Shokado Shojo, a Buddhist monk attached to the Iwashimizu Hachiman shrine, was also a student of the Son'en school at first, but revered Kukai and studied his style. His style is magnanimous and bold, and in *kana* as well his flowing graceful style has its own unique quality.

These three calligraphers all had their own individual characteristics, but what they had in common is also very significant. They realized that Japan could have its own unique art even at a time when Chinese culture was dominant, and proceeded to use their creative gifts to establish a uniquely Japanese calligraphy.

Whenever a great calligrapher appears, he sets up a school and imparts his techniques to his followers. This tendency persisted unchanged into the Edo period, and later, too, many schools appeared successively. The most influential among these was the Daishi school of Fujiki Atsunao, which, along with the O-ie school and the Jimyo-in school, was the center of gravity in Japanese schools calligraphy and continued to thrive for a long time.

From the Momoyama period the appreciation of calligraphy developed in connection with the tea ceremony. The practice of appreciating calligraphy in the form of fragments of old writings assembled into copybooks arose, and at last people appeared who studied the old calligraphers. Representative of these are Suminokura Soan, Kobori Enshu, Ryosho Shinno, and Araki Sohaku. In 1645 the *Honsho Meiko Bokuho,* a collection of famous calligraphy, was printed, copybooks in the *wayo* style were put together, and reproductions of old calligraphy were widely printed and circulated. Konoe Iehiro (Fig. 178) appeared around 1700 and, applying his wide learning, made copy-studies of every conceivable kind of good calligraphy, displaying a delicate critical sensibility. His lofty, elegant style became the inspiration of all students of calligraphy.

Generally speaking, however, the *wayo* style during the Edo period was suffering a slump and did not compare to the vigorous activity of the *karayo* calligraphers. There was virtually no *wayo* calligraphy worth speaking of apart from the little done by those *kokugaku* ("Japanese studies" as opposed to "Chinese studies") scholars and *waka* and *haiku* poets who happened to be good at calligraphy as well.

MEIJI AND MODERN CALLIGRAPHY

Along with the development of Western-style culture in the Meiji and Taisho eras, scholarly research and appreciation of the arts became progressively deeper and widespread. Among those who were looking for the real values of Japanese calligraphy appeared some who seriously took up Heian-period *wayo* writing, and so the ancient style rose again. Shin'ai Tada,

184. *Section of* Wakan Roei-shu *(Kumo-gami-bon transcription), attributed to Fuji-wara Yukinari. Eleventh century. Paper scroll; height; 27.5 cm. Imperial Household Collection.*

Masaomi Ban, Gado Ono, Shugyo Oguchi, and others were all influential in this *jodai-yo,* or ancient style of calligraphy. In addition it is noteworthy that Shimbi Tanaka reprinted and made known many fine works in the old style. Today too, the *wayo* style is still popular and constitutes a big sector of modern calligraphy.

INTERDEPENDENCE OF KARAYO AND WAYO

In the preceding we have given a brief history of the two traditions of *karayo,* Chinese style, and *wayo,* Japanese style. There has been, in every era, an interdependence between the two traditions. The influence exerted by *karayo* on *wayo,* and the adoption of *karayo* elements into *wayo,* had an important bearing on the development of the *wayo* style.

The *karayo* tradition in Japan has always directly reflected the changing styles of mainland calligraphy, albeit with a time gap of varying length. The *wayo* tradition, on the other hand, has always looked on the Chin and T'ang styles centered on Wang Hsi-chih as its basis, and since the Nara and Heian periods, *wayo,* as a softened version of this style, has developed as a great, independent tradition. Even today, there is something about Japanese calligraphy that retains the unchanged flavor of Wang Hsi-chih's style. During its long history, the appearance of a creative movement in *wayo* calligraphy has generally been coincidental with the introduction from the *karayo* style of elements foreign to the *wayo* style. And it seems that these periodic shake-ups served to regulate the strengths and weaknesses of the *wayo* style.

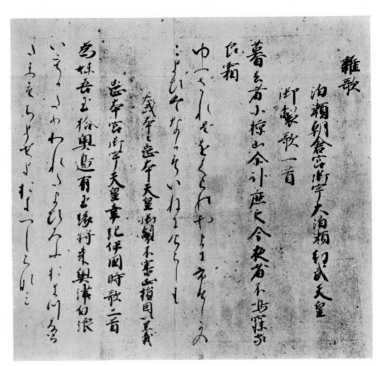

185. Section of Man'yo-shu *(Ranshi-bon transcription), attributed to Fujiwara Kinto. About eleventh century. Colored-paper scroll; height, 26.7 cm.*

The *karayo* tradition is rich in the variety of script styles and brush techniques used. It has a long, variegated history and a tradition of scholarship as a background. The style is masculine and three-dimensional, having the feel of architecture. It is characterized by a fierce spirit and strong willpower.

In contrast, the *wayo* tradition does not have such a rich variety of script styles, its brush techniques are delicately elaborate, and the style has a gentle, graceful, feminine feeling, like finely wrought works of craftsmanship. It is by nature simple and weak, with a chronic tendency to monotony. Somehow it seems to be lacking in virile willpower and profound intellectuality. Thus one gets the impression that it has a need to be stimulated now and again by something strong.

Looking at the history of *wayo*, we can see that each time it received a great impetus from *karayo* it took a new turn and faced a different direction. The *wayo* of the late Heian period was based on the style of the Wangs of Chin China, and the great calligraphers of the early Edo period drew on the spirit of Kamakura calligraphy, producing works characterized by the good aspects of its temperament. When *karayo* elements were introduced into the *wayo* style, it was not simply imitation. There was always a tendency to create a new, typically Japanese calligraphic art. In the late Edo period, Nukina Kaioku focused his attention on the T'ang works that had been brought to Japan and perfected the *karayo* style. This was possible because of a faith that there were masterpieces extant in Japan not inferior to those in China, and that a

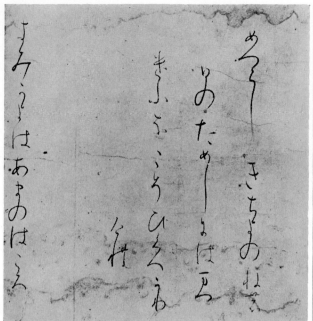

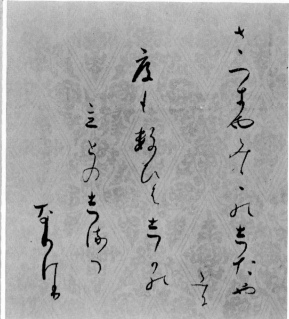

186. *Section of* Horai-gire, *attributed to Fujiwara Yukinari. About eleventh century. Paper; 25.4 × 24.2 cm.*

187. O-jikishi *(fragment of scroll of* waka *poetry). About eleventh century. Originally in scroll format. Karakami paper; height, 26 cm.*

fine calligraphic style had been cultivated in Japan on the basis of such works since ancient times. Taking the good elements of Chinese calligraphy and assimilating them, a truly excellent, creative Japanese calligraphic art was developed. This is one more hint of the future of *wayo* calligraphy: if no fundamentally different elements are introduced into *wayo*, there is the considerable fear that it will continue in lock step with the unchanged traditions of "schools" calligraphy. As long as a

purely utilitarian calligraphy is in question there is no problem, but when it comes to a creative art, it is impossible for good works to be created under such conditions. It is to be hoped that the *wayo* tradition will not stagnate in self-complacency, but, stimulated by some great external influence, will develop for itself a fresh, original world.

Fortunately, modern *wayo* has already pushed such worries aside, and is developing a broad-minded, beautiful calligraphic art.

TITLES IN THE SERIES

Although the individual books in the series are designed as self-contained units, so that readers may choose subjects according to their personal interests, the series itself constitutes a full survey of Japanese art and is therefore a reference work of great value. The following titles are listed in the same order, roughly chronological, as those of the original Japanese versions, with the addition of a cultural appreciation (Vol. 30) and the index volume.

The "weathermark" identifies this book as having been planned, designed, and produced at the Tokyo offices of John Weatherhill, Inc., 7-6-13 Roppongi, Minato-ku, Tokyo 106. Book design and typography by Meredith Weatherby and Ronald V. Bell. Layout of photographs by Sigrid Nikovskis and Ronald V. Bell. Composition by General Printing Co., Yokohama. Color plates 11-16 engraved and printed by Mitsumura Printing Co., Tokyo, the remainder by Benrido Printing Co., Kyoto. Gravure plates engraved and printed by Inshokan Printing Co., Tokyo. Monochrome letterpress platemaking and printing and text printing by Tokyo Printing Co., Tokyo. Bound at the Makoto Binderies, Tokyo. Text is set in 10-pt. Monotype Baskerville with hand-set Optima for display.